SEP 2 9 2016

THE
ORIGINAL BATTLE CREEK
CRIME KING

THE

ORIGINAL BATTLE CREEK CRIME KING

ADAM "PUMP" ARNOLD'S VILE REIGN

**BLAINE PARDOE &
VICTORIA HESTER**

THE
History
PRESS

Published by The History Press
Charleston, SC
www.historypress.net

First published 2016

Manufactured in the United States

ISBN 978.1.46711.929.0

Library of Congress Control Number: 2016936021

To Rose Pardoe—mother and grandmother. She was ill during the writing of this book and had to endure one of the author's (Blaine) writing passages and the reading of them to her. We all had a good chuckle at the exploits of Pump Arnold long before they appeared in print.

CONTENTS

THE SOUL OF A CRIMINAL

This is the Blackest Crime that has Stained Calhoun County's History.
–Battle Creek Moon, "In Jail, Is A.C. Arnold,
Charged with the Murder of His Son," February 8, 1895

When people talk of Battle Creek, Michigan, it is almost always framed, in some manner, around the cereal industry. If the historical subject is not part of that story, it certainly provides the backdrop for any tale of the city. It is the community where the world's breakfast has been made for decades, so that is understandable. Post, Kelloggs and Ralston Purina often define the city in the minds of many people. There was a time, though, when that wasn't the case.

In the early years of Battle Creek, it was a wild town, considered in "the West" and "the Michigan frontier." It was a city that was a religious center—the headquarters of the Seventh-Day Adventist Church. In those early years, it was an industrial town where numerous industrial businesses thrived. Battle Creek, for many years, was a publishing mecca, one of the largest producers of the printed word outside New York. Battle Creek, Michigan, is every midwestern city in the United States. In its positioning on major rivers and its reliance on certain industries for growth, the Victorian-era Battle Creek is indistinguishable from almost any other city of its size. This was all in those years before words like "Corn Flakes" or "Postum" were known to the world.

Battle Creek clings to the cereal years as its heyday, making stories from this period rare. Adding to the complexity for writers, the documentation

Pump Arnold, the scourge of Battle Creek. *From the* Battle Creek Moon, *February 11, 1895.*

tends to be fragmentary. The early settlers documented their accomplishments, but in-depth histories are uncommon. The stories that stood out are the big events and the big people. Such is the case with Adam C. Arnold—or, as he is better known, "Pump Arnold."

Pump Arnold has been described as "the greatest criminal in the history of Battle Creek." Certainly he was a man who treated the law as nothing more than a rough guideline through his life—one he often ignored. If published accounts from the period are correct, Pump Arnold was a pawnbroker, a retailer, an assassin, a manufacturer, a saloonkeeper, a self-proclaimed druggist, a hotel operator, a bootlegger, a pimp, a bartender, a gambler, a gang leader, a blackmailer, a land speculator, an arsonist, a loan shark, a reckless driver (he ran over a young boy), a swindler, a semisophisticated con man, a robber, an accomplished liar and a murderer (specifically paternal filicide). And these are the crimes that we know of.

Pump Arnold's story is one of enterprise. He built an empire estimated to be worth $100,000 in the 1890s (millions in modern dollars), yet he died with little more than debt and unfulfilled dreams. Arnold built his vast holdings on the sins of man: the quest for flesh and liquor and the greed tied to gambling. Arnold built a monument to greed, gambling, prostitution and liquor: the Arnold Block. Despite all of this, he is often a bit of a paradox. As one newspaper account put it in 1895, "One of the old man's redeeming features is that he never drinks. He has been in the whisky business almost continually since 1857, but in all that time has not been drunk. He has been arrested innumerable times but has never served a sentence. The fines he has paid for violating the liquor law would make a poor man rich." While Pump never consumed liquor, it would consume his son's life. Perhaps the sins of the father were passed to his child?

Drawing of the Arnold Block by R.L. Cashe for *Heritage Battle Creek*.

Why write a book about such a clearly corrupt man who utterly lacks any moral compass? Simply put, our history is often defined by the crimes and our criminals. Pump Arnold allows for a telling of a part of Battle Creek and early Michigan history that might normally be ignored. Moreover, every

city in America has a Pump Arnold in its past—an individual who pushes the limits of ethics and the law. He provides context for the emergence and explosive growth of the city. Arnold may have been a nasty legal/moral rash on the early years of Battle Creek, but he offers us a glimpse of the Victorian-era sensibilities in Michigan by his constant violation of them throughout his life.

Another compelling reason to write about the Arnold clan is that Battle Creek strangely and fondly remembers him, with tongue firmly planted in cheek. It is as if his murder of his son, George, gets glossed over with stories of a hobo statue or tricking the Woman's Christian Temperance Union to purchase him, the city's greatest purveyor of liquor, a tombstone. Such a character is worthy of researching and documenting.

This is the first, and likely only, true crime book we've ever written that has many funny moments in it. We tried to preserve that sense of whimsy tied to his criminal lifestyle in our writing, and we hope you enjoy it. Pump Arnold is an usher, a guide of sort, through the history of an emerging industrial community at an exciting time in the history of our nation. As writers, we merely went along for the ride, with a madman driving the carriage.

That doesn't mean we set out to whitewash his legend. This journey is one that is tied to the "biggest criminal trial in the history of Battle Creek." The story of Pump Arnold is interwoven with that of his victim: his son, George Arnold. In some respects, there are elements of a Greek tragedy that unfolded between the two of them. It is not just the story of father and son. Both men struggle with their demons. Adam's wife and George's mother straddled the upper crust of society while her husband catered to its underbelly. She battled throughout her life to hold together some fragment of normalcy in her family, while both son and father sought to tear it and themselves apart. Ultimately, Pump embraced the evil that resides in all men, whereas George became a victim not only of his inner demons but also of his father's rage.

ACKNOWLEDGEMENTS

W e would love to claim credit for coming up with the idea for this book, but it really came from Mary Butler and Elizabeth Neumeyer of Heritage Battle Creek. They said, "We think there's a story there with Pump Arnold." They were right, although we weren't sure where this story was going when we started it. Heritage Battle Creek was beyond supportive in our research efforts.

Jean Armstrong did a phenomenal job in doing genealogical research for us. Jean left few stones unturned in helping us out.

George Livingston of Willard Library was a massive help in getting some of the key images for the book. George is a treasure of local history knowledge.

Walter Jung helped with early images of Battle Creek.

Robyn Conroy, librarian of the Worcester (Massachusetts) Historical Society, helped us out tracking down George's time at the military academy there.

The U.S. National Archives still photography staff were a huge help in finding the lone photo album of the Michigan Military Academy.

Verona town historian Sheila Hoffman gave us a wealth of material on Pump's early years.

Nate Palmer, assistant director/head of systems at the Marshall District Library, bent over backward to get us access to its archives.

Mitch Grady of the Livingston–Park County Montana Public Library offered his history of Livingston.

This was not an easy book to write. Battle Creek has changed street names often, making the identification of the location of certain businesses often

difficult. Jefferson Avenue has become Capital Avenue, for example. Canal Street became two different State Streets, in a city with two more State Streets. In the book, we have used the street names associated with the period.

Pump Arnold's myriad businesses, including his hotels and bars, were often leased to others to manage for him. The Arnold Hotel (aka the Exchange Hotel) underwent no less than six different names in his lifetime, as well as a larger number of managers. We opted to not bog down the book with the legal naming unless it added something to the story for context.

When it comes to names, we often went with what was in the newspapers of the era, which can lead to some mistakes. Adding to this is the fact that people of the era often changed their last names. We went with what census records showed.

GEORGE ARNOLD IS FOUND!

George H. Arnold was born in this city on Feb. 17. 1860, and would have been 35 years old on the 17th of this month. He received a good education at the public schools of this city, and also attended the Military Academy at Worcester, Mass, for two years, receiving a good military education there.

–Battle Creek Moon, *"His Body Found,*
How Did George Arnold Come to His Death," February 1, 1895

February 1895 began with biting cold. December and January had been one wave after another of below-freezing weather as well, though with only a spattering of lake-effect snow. Some Michigan winters were mild, some were thick snowstorms and others were stinging cold weather. Battle Creek was situated just close enough to Lake Michigan to be affected by the lake during the winter. The winter of 1895 was proving to be a particularly hard one. Two days earlier, the temperatures had only reached a high of ten below zero. As with most people in Michigan, the start of February meant that people could start looking at only another month or two of winter before thoughts of planting could begin.

On Saturday, February 1, Frank H. Bauchman went to work at Clapp Lumber on Battle Creek's West Canal Street, as he did every morning. Lewis Clapp ran the business, having come to the area as one of the first pioneers in 1845. Mr. Clapp's lumber company was one of his two businesses, the other being the largest cigar manufacturer in town.

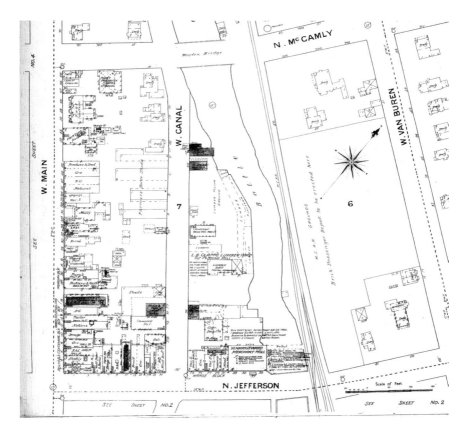

Sanborn Fire Map showing Clapp Lumber, where George's body was found along the Battle Creek River. *Courtesy of Willard Library, Battle Creek.*

Bauchman's work for that morning was to stack lumber in the sheds. The sheds of Clapp Lumber were built on pilings extending out over the Battle Creek River. The work was doubly cold on those days. The sheds were not heated and hanging over the river; with the wind able to penetrate below, above and around the sheds, they were anything but warm. Adding to the cold was the wind; it was gusting, making the air like a swirling sword that tried to cut any exposed flesh. The key was to keep moving on such days and stay indoors as much as possible. Bauchman was not a native of Battle Creek. He and his wife hailed from Pennsylvania. He had been working for Clapp Lumber for some time as a teamster and a general laborer.

At about 8:00 a.m., he moved into the shed and began his work. The wind was blowing in bursts outside, penetrating every crack in the shed. A strange noise caught his attention under the floorboards of the shed. It was

the sound of something flapping in the wind. Bauchman's first thought was that it was a turkey that had gotten away from a butcher, fluttering on the riverbank under the shed for shelter. It had happened before, a bird making a desperate break from the butcher's cleaver. Looking down through the cracks in the floor, he could see that something was under the shed on the river, but it wasn't the expected bird. Getting down on his hands and knees and squinting through the gap between the floor planks, Frank Bauchman was stunned by what he saw. There, half on the shore and half in the water, was the pale body of a man—his clothing fluttering in the breeze. He was lying on his back, almost as if he were relaxed or deliberately laid there. The man's lower extremities were entombed in a slab of ice that extended into the river under the shed.

Startled by the find, he rushed to the Clapp office and got on the telephone to inform the authorities. The telephone arrived in Battle Creek in June 1882, and the cumbersome network of poles and wires had changed the skyline of the city. Just over two hundred citizens and businesses even had the new technology. Bauchman called Bell Telephone Exchange and was put through to the coroner, the Battle Creek Police Department and the *Daily Moon* newspaper, one of the two newspapers operating in Battle Creek at the time. The first to arrive on the scene, just before the coroner, was the *Daily Moon*'s reporter. The police arrived several minutes later. A dead body in Battle Creek was big news, and the *Moon* loved nothing more than scooping the competition, the *Battle Creek Daily Journal*, on a headline story.

Getting to the body was not going to be easy. If it had been warm weather, a boat could have been put into the river, but with ice formed along the banks for the last few weeks, boat navigation might prove hazardous. The solution that the small group of men came to was to pry up the floor planks of the shed to access the body from above. As their breath frosted in the air, they carefully removed some of the planks to get to the river. Looking down the four feet to the icy bank, the group saw the body clearly. It was face up, with the upper torso laying on the frozen mud of the river, while the lower extremities were encased in river ice. It was George H. Arnold.

The men all knew George Arnold by reputation if not personally. He was the twenty-nine-year-old son of Adam C. "Pump" Arnold, owner of the Arnold Block, a hotel and bar only three blocks away. Pump Arnold was well known as a loan shark and a potential pimp, as well as for selling liquor illegally. Arnold was unabashed about his nefarious activities. When sued or fined, he treated it as merely "the cost of doing business." George was his only son and had been missing since the evening of December 16.

George was well known in his own right, although not in a positive way. The citizens of Battle Creek had come to know him as a disruptive alcoholic. When not quarrelling with his father, George spent many days in the circuit court in Marshall, Michigan, on one charge or another—almost all of them linked to his drinking. George was known to be just as violent as his father, too, which did not endear him to the citizens. Still, few wished anything ill on George. Other than his father, George did more damage to himself than anyone else could. If anything, there was a sense of sadness that followed him like a dreary gray shadow. Where Pump was involved in a number of criminal activities, George was somewhat sadly pathetic. There were other men who drank as much as he did, but few who were so widely publicized in the newspapers. He had lived his life as an echo of a man who was a dominant force in Battle Creek, for good or ill.

George's disappearance was not entirely out of the ordinary, as he had wandered off for weeks at a time before. His father suspected foul play or worse, suggesting that George had done something to himself. According to the elder Arnold, George had wandered off into the winter night in December allegedly in a delirium. There were rumors for some time that George had been having visions of his dead mother. Pump had offered a twenty-five-dollar reward for information on George's whereabouts. The millrace had even been drained in an effort to try to locate him.

Battle Creek coroner Dr. Leon M. Gillette arrived while John H. Mykins, the undertaker, was leading the effort to free George's body. Working in the cramped space, the handful of men, armed with picks and axes, chipped away at the ice and earth to which George had become frozen. The task initially proved beyond their brute strength. George was embedded in the bank of the river mud and frozen solid. Weeks of biting-cold temperatures made his extraction more complicated. They heated up a plumbers' stove and used a steam generator to heat up water and pump it around the body in an attempt to thaw him free. Despite the efforts, George's corpse clung to the embankment. Mykins ordered crowbars to be brought into the cramped space, and finally they were able to loosen the young Arnold's body, prying it and clumps of frozen mud along with it. It was the kind of work that no one would have enjoyed. Working up a sweat in that weather was a good way to get sick, so the men took turns in the tight space under the shed, while their colleagues tried to warm themselves. Ropes were lowered, and George was hauled up to the shed.

The men loaded the body onto an express wagon, and it was taken to Mykins's business, where it could be thawed and made presentable for

Undertaker John Mykins, who performed the autopsy on George Arnold. *Courtesy of Willard Library, Battle Creek.*

burial. At the same time, Dr. Gillette convened a quick coroner's jury with the purpose to determine if a potential crime had taken place. Constable Hamilton rounded up several local citizens to take part: Howard Baker, Chas. Kraft, Alex Finley, Clarence Severance and Henry Wiswell. Prosecuting attorney Orange Scott Clark joined them at about 2:00 p.m. The group assembled at Mykins's undertaking rooms as he attempted to finish his grim work.

George's body was relatively well preserved thanks to the Michigan winter. The right side of his face bore two wounds, one being at the temple and the other, somewhat larger (three inches long), extending along his jawbone and into the neck. Given the limitations of forensic science at the time, it was hard for the coroner's jury to tell if the injuries took place at the time of death or as a result of hitting the pilings under the shed. George's body was not bloated from expanding gases but rather appeared natural. His eyes and mouth were open, staring into nothingness. The disposition of the body led the men to believe that George had been placed under the shed rather than had floated there. The river had not been high enough in the last month to have cast the body there naturally.

His arms were found crossed across his body. George's hair was not frozen, as it would have been if he had drifted in the river under the shed. The upper portion of his body, which was out of the water, was frozen but otherwise relatively limp, not rigid as if he had been totally soaked and then frozen in the embankment. To the gathered men, it appeared as if George had not been tossed or had fallen into the Battle Creek River; rather, he had been carefully concealed under the shed, out of sight of the opposite bank.

Constable Hamilton sent for Adam Arnold shortly after the body of his son was recovered. The elder Arnold seemed to be shaken but long expressed that he had been confident that George's remains were in the river. Indeed, he had made little effort to hide that fact from the public since George went missing in December. Five days after his disappearance, the *Battle Creek Moon* newspaper had reported, "A.C. Arnold had given up all hope of finding his son George alive…he believed George is drowned." It went on to describe Pump's state of mind: "This morning Mr. Arnold expressed himself in the presence of Sheriff [David] Walkinshaw as believing George was dead. The sheriff said that he did not believe it and that George would turn up all right. He offered to bet Arnold $10 that George was alive and Arnold took up the bet and deposited $10 each in the hands of Deputy Sheriff King." The ever-cold Adam C. Arnold was quite literally gambling with any takers that his son was dead.

For many Battle Creek citizens, there was a hint that Pump might have reason to believe that. The fights between father and son were often public affairs, being covered in the newspapers and the subjects of many trips to court. George's own frequent drunken debauchery often painted him as a sad laughingstock. The physical knock-down, drag-out fights he had with his father cast a great deal of suspicion on Pump Arnold, who was betting that George had finally met his fate.

Pump's own examination of George's remains and discussion with the coroner's jury led him to state that he was confident that George had not drowned but rather met his death "by foul play." Pump went on to state that he believed that his son's remains had been placed under the Clapp Lumber shed by boat. If he had been merely dumped into the water, he would have floated farther downriver before coming up on shore. This added to suspicion because Pump had organized nighttime searches of the river, any of which may have played a part in depositing George's remains.

Dr. Gillette struggled to attempt a postmortem on George, given that his body was still frozen. He was joined in his efforts by Dr. E.W. Lamoreaux, but even with his colleague's assistance, there was little that they could do. They agreed that it would be best to continue their work once he thawed. They agreed to adjourn the coroner's jury until Thursday, February 7, at Gillette's office.

Prosecuting Attorney Clark and Calhoun County sheriff David Walkinshaw asked Gillette's his opinion as to George's demise. His answer was simple. Dr. Gillette believed that George had not drowned but rather "had met his death by foul play."

As to who would want to kill George Arnold, most cast their suspicions on one of the last men to see him alive, a man who had bet that he was dead: his father, Pump Arnold.

PUMP'S NEW YORK YEARS

The Utica (NY) Herald says strong suspicions are indulged in at Oneida, that the house of Mr. Adam Arnold—which was recently destroyed by fire—was purposefully fired for the purpose of getting the insurance. Mr. Arnold has left for parts unknown.
–Extra Sun, New York Sun, *April 19, 1856*

Adam C. Arnold was born to George and Sophia Arnold in France on December 20, 1829. His father, George, was a farmer by profession. While it cannot be completely confirmed, there was a George Arnold born in 1788 in Chenicourd, Nomeng, in the Alsace-Lorraine region nestled between France and Germany. During the U.S. Census in his lifetime, George Arnold would claim that he was born in both France and Germany, which certainly fits that Alsace region, which flip-flopped ownership between the two countries constantly during the period. In his immigration to the United States, he claimed that "the country to which they severally belong" was France.

At the age of three, Adam's family left France from La Havre, France, aboard the ship *Rhone* bound for the United States. With his parents was Marguerite and Salome, presumably his sisters, with Salome being only nine months old. They arrived in New York City on August 4, 1832. Shortly thereafter, they moved to the village of Verona, Oneida County, New York.

Such trips during the early 1800s were done on rickety, often unstable ships. It was a costly affair, often running as much as a person made in a single year for one person to make the voyage (less for children). Immigrants

traveling from France and Germany had no guarantee that they would survive the voyage across the Atlantic. With no weather service or means to predict the conditions, such trips were often risky. It took special people to determine that it was better to risk their lives and the knowns in their native countries to travel to an unknown nation across treacherous waters. More often than not, it was economic downturn that drove farmers like the George Arnold family to take the risk.

What drew the Arnolds to Verona is not known with certainty. There was another Arnold family, that of Frederick Arnold, who had settled in Oneida County several years earlier from Wurttemberg, Germany. This opens the possibility that the two families were related, even if distantly. Regardless of reason, the Arnolds moved to rural New York, and George and Sophia settled in to become a farming family. They had picked a wonderful locale for their new lives, a conservative part of the countryside where people had good values and religious sensibilities. Shortly after their arrival, Sophia gave birth to at least one other child, a son named Martin, Adam's brother.

Verona, New York, was an idyllic rural setting, in stark contrast to the boy who would be raised there. The village had been formed only three decades before the arrival of Adam Arnold's family, in 1802, although the region had been settled as early as 1792. The village resembled more of an English countryside than the Alsace-Lorraine region, with rolling grass-covered hills, many streams and creeks for ample irrigation and rich soil for growing grain crops. Dairy farms were commonplace, as were farmers raising wheat. Oneida County was best described as pastoral. For a small community, it had a lot of churches, including Catholic, Lutheran, Presbyterian and Baptist. Utica, New York, was the nearest big city. The people of Verona were highly self-sufficient during the early years.

The village had access to the New York Central Railroad (or its earlier vestiges) in the mid-1800s, but the true lifeline for the area was the Erie Canal. The canal was not only a stunning engineering feat that connected the East Coast with the burgeoning then western states, but it was also a highway for goods and people to travel. In 1835, the twenty-one-mile Lake Oneida was connected to the Erie Canal system.

Canals were the superhighways of their days. They allowed the safe transport of goods over vast distances in what was then record time. The system ran north of Verona and is often referenced as a dividing line in the county for those who lived north or south of the canal. Until the arrival of the railroads, the canals often defined the success of small communities such as Verona.

The Erie Canal affected not just New York but the entire country. It allowed families to safely transport their entire households (and livestock) across a vast portion of the country in relatively fast time. Up until the creation of the canal, travel across the United States was a slow and dangerous proposition, limited to what you could carry in a wagon. Roads were little more than converted Indian footpaths, deep muddy ruts where progress was measured in painful miles.

The people of Verona prospered from the canal cutting through their county. Farmers could sell their goods to travelers or for shipment back to New York, depending on which direction the barges were traveling. Inns sprung up for travelers to sleep. For the pastoral village of Verona, the Erie Canal would have also been a source of entertainment—watching families heading west, imagining what adventures might await them. Immigrants from faraway lands passed through their community daily.

For Adam Arnold, it would have been a constant, almost nagging reminder that there were fortunes to be made out west, away from where he was. Adam's early childhood would have been centered on working the family's farms. The Arnolds owned two plots of land in the county, each about twenty acres. Little exists in the form of records from the time when young Adam Arnold was being raised. Little was ever published about his education. What is known about him indicated that "Oneidans recall him as a rather spirited young man, fond of sportive pastimes." Sports were limited during this period of America. Baseball was being played in the United States starting in 1791; although it was still in its infancy in terms of play, it would have likely been one of Adam's sports. Boxing was not very popular in rural New York, but foot and horse racing would have been considered sporting activity.

Adam's school records no longer exist, but chances are that he only attended a few years of formal education—at most through what would be the equivalent of eighth or ninth grade. Oneida had a very rudimentary schooling system: single-room schoolhouses, enough to teach the basics of reading and math. Of course, working on a farm would have given the young Arnold a good understanding of economics and business skills.

Little is known of the young Adam Arnold until the 1850s, as he came into his own. His father, George, began to make investments in property and purchasing mortgages—this was an endeavor that must have appealed to the young Arnold, much more than the hard work of a farm. In the early 1800s, most people did not go to the bank for a traditional mortgage to purchase property. They entered into property chattels, or contracts, agreeing to pay

the owner over time. It was not uncommon for someone to sell a mortgage to someone else, giving them title to the property if the person failed to fulfill the terms of the loan. The trading of mortgages, even exchanging them for livestock or other property, became a form of land speculation that was popular. In many respects, it was gambling where the stakes could be substantial. Foreclosing on property often meant quick profits, despite the suffering of those who lost their homes or farms.

Like most young men, Adam's attention soon turned to women. He became attracted to Maria (Marian) Dygert of Verona. Her family were farmers like his own, with Henry Dygert owning two large farms. By most accounts, Maria was a soft-spoken woman. She was described in several accounts in her life as a being gentle, quiet and highly respected. In most aspects, she was the opposite of the man she fell in love with.

Adam married Miss Maria Dygert on New Year's Day 1856. According to the *Oneida Sachem* newspaper, "Another Arnold has been beguiled by a woman! May he never like his namesake of the Revolutionary memory, prove a traitor to her; and by the New Year so auspiciously begun lead him save through the besetting temptations of life, in the paths of Virtue, Prosperity and Peace. P.S. Mr. Arnold called to day, paid one dollar for this above notice, and $1.25 for one year's subscription to the Oneida Sachem, in advance. Mr. Arnold is all right!" Even as a young man, Adam worked hard to craft his public image. The newlyweds began the construction of a new home in the village on a parcel of land that Adam had secured during one of his many real estate transactions. For all intents and purposes, it looked as if Adam Arnold was settling in to be an upstanding member of the Verona community. His success was crafted on a house of cards, though, one that was to tumble in just a few short months.

The lure of making money without the backbreaking effort of farming would have likely been the initial appeal to Adam. Like his father, he began to make a living purchasing and selling chattels and mortgages. The largest of these involved one Timothy Cahil, who defaulted on his mortgage. Adam looked to be making a significant profit, but something clearly went wrong with the sale. Rumors flew that Adam was involved with shady purchases that were barely legal. While the details of his alleged wrongdoings were never fully disclosed, one thing was clear: Adam was in severe financial and legal distress and had broken the law. It was an inauspicious start to his married life.

Rather than own up to the problems, Arnold took a more drastic step. On March 20, 1856, he set fire to his new home. It was reported in the *Oneida Sachem*:

Fire! The new dwelling house owned and occupied by Mr. Adam Arnold on the north side of the Railroad, on the Durhamville road in this village was entirely destroyed by fire on Friday night. Before it was discovered, the flames had spread so far as to render any attempts at saving the property useless. Mr. A. and the family were absent at the time of the conflagration, and every article of furniture and clothing in the building was wholly destroyed. $700, in bills on the Bank of Rome, Bank of Verona, and Oneida Valley Bank, were in the house at the time. The fire was undoubtedly the work of an incendiary, and circumstances seem to indicate that the money was first stolen and then the building fired. We trust the scoundrels who perpetrated this daring act may be brought to justice. Mr. Arnold had an insurance of $750, on the building and furniture.

Adam went on to claim that all of the paperwork he had that would prove his innocence, along with his mortgage contracts, had been lost in the fire. He claimed as well that he had $700 in the house at the time that was lost in the conflagration. The amount of money lost was equal to more than $18,000 in modern dollars, an incredible sum. Better yet, it cast the illusion that Adam was not having financial difficulties at all. For a few days, Arnold played out the role of victim. He and his new wife lost most of their worldly possessions and their money. Adam had insured the house only a few weeks earlier, which led to the suspicion that there was more to the fire than a mere accident. Insurance policies on private homes were not commonplace in the era, and the fact that the fire took place in the middle of his legal issues—and destroyed the alleged evidence that would have helped him—only seemed to cast more public doubt in the story that Arnold wove for public consumption.

In early April 1856, Adam did something that only seemed to add validity to his critics: he left Verona for parts unknown. As reported in the *Oneida Sachem* on April 12:

Suspicion! Strong suspicions have been excited in this village, that the fire which destroyed Mr. Adam Arnold's residence was not altogether accidental, and that it might have taken place form a desire to get the insurance money. It is generally supposed that the story of him losing $700 in money at the time of the fire, is pure fiction. We understand that the Insurance Companies intended to resist the payment of money. Mr. Arnold has left town in a mysterious manner, leaving a large number of creditors and accommodation endorsers to "whistle for their pay."

Arson, fraud and other charges seemed to hang over the head of the young Arnold. His young bride, Maria, was left in Verona with her family to fend off the accusations, while Adam disappeared for parts unknown.

Arnold was gone for almost a month before returning to Verona the first week in May. He made his return appear to indicate that he was apparently coming back to face justice and set matters straight, something that the good citizens of Verona would have respected. The local newspaper recorded his arrest with a certain amount of relief on May 2, 1856. "Mr. Adam Arnold, whose sudden disappearance we noted several weeks since, made his appearance in our streets on Friday last—having returned voluntarily. He was forthwith arrested by a Deputy Sheriff of Oneida County, and conveyed to Rome to answer to the charge of procuring notes and endorsing paper under false pretense. It is thought that he will be released on bail."

There were no queries as to where he had gone, only relief that he had returned. His alleged crimes, however, had been the focus of the local gossip. Arson was a crime that did not happen often; in fact, in Oneida County, the last reported incident had been nearly fifteen years earlier. Combined with his insurance fraud and the mysterious loss of paperwork, it was no surprise that the citizens were chatting a great deal about the twenty-seven-year-old Arnold.

Rather than lie low and let the gossip mongers have their way, Arnold opted for another tactic, one that would be a pattern for him most of his life: he went on the offense. One week after his arrest, he arranged his bail and was freed. "Adam Arnold, whose sudden disappearance we noticed several weeks since, has made his appearance in Oneida, the *Sachem* says, on Friday last, having returned voluntarily. He was forthwith arrested by the Deputy Sheriff of Oneida County, and conveyed to Rome to answer the charge of procuring notes and endorsed paper under false pretenses. He has been released on bail, and is threatening some of those that have been talking about him with libel suits." Three days later, Arnold continued on with his threats to level lawsuits at those who were smearing his reputation: "Arnold, who was being held in the jail in Rome, New York, made bail and was released. Arnold wasted no time in laying out accusations against those that had been talking about him since his departure, threatening libel and defamation lawsuits against those that had wrongly accused him of committing a crime."

The threats of the lawsuits created the illusion that he and Maria planned on remaining in Verona and fighting the laundry list of charges leveled against him. Instead, he did something that surprised everyone. Gathering

up his new bride, they purchased passage on one of the barges heading west and left Oneida County behind forever.

What everyone in Oneida wondered was, "Where did Adam Arnold go? Where had he disappeared to for a month before he came back to get Maria?" Although there is no tangible evidence of where he went for a month, it is most likely that he went to find a place in the western states, a place where he could get away from his legal problems and start over.

What is known is where he and Maria ended up—most likely the same place he had scouted out a month earlier. They arrived in Battle Creek, Michigan, at the fringe of Michigan's western frontier.

A.C. ARNOLD OF BATTLE CREEK

Battle Creek has its share of legendary characters. To get to be a legend, it seems one must be extra good or extra bad. A.C. Arnold, known locally as Pump Arnold, was a character mostly bad. He should have died in jail.
—Bernice Bryant Lowe, Tales of Battle Creek, *1976*

When Adam Arnold arrived in the village of Battle Creek in May 1857, it bore little resemblance to the community that would be known around the world as "Cereal City." The village was still in its formative stage, still striving to find its identity. It was a community that was growing; its people were open, tolerant and welcoming. In other words, it was the perfect place for Adam to create a new life, a new persona, and refine his criminal behaviors. The community with open arms had no chance to keep his hands off their wallets.

Before Arnold's arrival, Battle Creek was considered the frontier. Michigan was a territory for years, only becoming a state some twenty-two years before Adam and Maria Arnold arrived in the village. There had been waves of migration to the territory in the early 1830s, mostly from upstate New York and Pennsylvania. The allure of cheap, fertile land, at $1.25 per acre, seduced many to seek out a better life on the frontier.

The early settlers discovered that the land was already occupied by the Native American population. The Pottawatomi Indian tribe predominated in the land that would be Calhoun County, where Battle Creek was located. Calhoun had been initially divided into twenty townships. A single township

could support no more than sixty to sixty-five Native Americans, with the largest concentration being in the Athens, Michigan area. For the most part, the Pottawatomis were friendly to the newcomers, but as they arrived in greater numbers, tensions began to surface. It was one of these incidents that led to Battle Creek getting its name.

The community name came from John H. Mullett and his surveying party having a skirmish with natives. Colonel Mullett was born in Halifax, Vermont, on July 11, 1786, and his family moved to Genesee County, New York, in 1807. He served in the War of 1812 and moved to Detroit in 1818 to be a tailor. General Lewis Cass, the territorial governor, appointed him as surveyor in 1821.

In the spring of 1825, Mullett and his party endured an encounter with the local Pottawatomis that led to the naming of the stream/river as "Battle" Creek. The natives had long referred to the river as Waupakisko. The Indians had been troublesome for the surveyors, but more as nuisance than threat. That changed on March 14, when a small group of Indians got into a fight with Mullett and his men. Guns were fired and men beaten, but no one was killed. Thus ended the "battle" for which Battle Creek was eventually named. In an era when surveyors struggled to name every geological landmark, they merely defaulted to the easiest of references—named after little more than the equivalent of a mugging attempt. While popular myth purports that the skirmish took place where the city of Battle Creek would be formed, the reality is that it took place much farther north, near Bellevue, Michigan.

The settlement of Battle Creek (known as Milton until the city formation) was one driven by the waterways, where the Kalamazoo and Battle Creek Rivers converged. The land between the two rivers was rich, with good bedrock and ample access to water, which was critical for communities. There was a steep drop in the water in this area that could serve as a possible source of power for industry. The surrounding area itself was dotted with lakes and ponds, with much of the ground best described as swamps—horrible bogs difficult to navigate. The few roads cutting through the area consisted of little more than Indian footpaths that settlers followed with their wagons. When wet, they became deep, muddy ruts that often consumed the wagons that tried to traverse them. It often required a large team of oxen to pull one free—only to have it get stuck again. Bridges were a rarity, as most wagons had to ford the rivers. They were lucky to average a mile and a half per hour trying to reach Calhoun County in the 1830s.

There was a scramble of sorts to form new towns. This was an era when a visionary man with a few dollars could establish a community in his name.

Such a man was Sands McCamly of Orleans County, New York. McCamly and other men, John Guernsey and Lucius Lyon, recognized the potential of the waterways for a future converging where downtown Battle Creek would one day emerge. At the time, it was merely a notation on the map, the township of Milton. In 1831, they jockeyed for control of the land in the downtown area along with several other investors. It took several years for McCamly to eventually consolidate his holdings for the heart of the village. On March 13, 1834, he along with other investors, including General Ezra Convis, drafted the original plat for what would be Battle Creek, securing more than eight hundred acres at the joining of the two main rivers.

Sands McCamly is rightly credited with having the vision to see the potential of the new village of Battle Creek (Milton). In 1835, only "five or six families, number in all about 50 souls," resided around Battle Creek. It was in this year that McCamly organized the largest engineering feat in the region at the time: the digging of a canal system to harness the water power. He organized a crew of twenty-five to forty local citizens, Indians and itinerant Irish workers to dig a one-and-one-quarter-mile-long canal system, known as a millrace. One local dubbed the effort "a monument to noble enterprise." It was started upstream, before the drop-off in the river, to ensure a strong flow of water that could be harnessed by industries that

4468. Mill Run, Battle Creek, Michigan

View of the millrace that Sands McCamly dug that led to the settlement of the city. *Author's private collection.*

might settle there. The canal was forty feet wide and four feet deep. Over the next two years, he expanded the millrace, adding side canals known as tail races. The canals connected the Kalamazoo and Battle Creek Rivers and had wooden locks that could be closed as dams in case the millrace had to be drained or regulated.

In some respects, the canal system gave Battle Creek an almost Venetian appearance, with the waterways challenging the number of streets in the tiny village. At the same time, these were dumping grounds for the homes and businesses along them, carrying human sewage and garbage away downriver.

With the water power came enterprise. George Willard, one of the early settlers, set up the area's first up-and-down sawmill. By 1837, Battle Creek could claim to be a good-sized village, with "six stores, two taverns, two sawmills, two flouring mills, two machine shops, one cabinet factory and two blacksmith shops." McCamly opened his own gristmill as well later that year. The mills became important, as they allowed farmers to plant grains and process them for use without the use of grueling manual labor. With mills, farmers were encouraged to purchase land to raise crops. Potatoes and grain were the most common, although the rich black soils proved able to support almost anything.

As the fledgling village grew, it became more accessible. The roads were improved, and stagecoach service began to run from Detroit. While water

Battle Creek River, Battle Creek, Mich.

The view of the Battle Creek River as it winds into downtown, roughly 1880–90. *Author's private collection.*

provided the power, it was already being replaced by the railroad as the means for long-distance transportation. Railroads were much faster than ships and were not confined to the coasts. The state government approved a rail line for the Michigan Central Railroad to run through Battle Creek in 1834. There had been concerns about running the line through Battle Creek proper. With locomotives chugging along at the breakneck speed of twelve miles per hour, there was fear that oxen and cattle might be killed by the racing trains. The Michigan Central Railroad reached the village on August 10, 1844, running along the north bank of the Battle Creek River, with the first trainload of passengers arriving in December of the following year. Suddenly, the village was no longer on the frontier but rather was connected with Detroit and, a few years later, Chicago.

The people of Milton/Battle Creek were small in number at the time. In the 1850 census, Battle Creek was a tiny village, almost insignificant. Grand Rapids had a population of 3,147 and Jackson 2,363, and Marshall, the county seat of Calhoun County, had 1,972. Battle Creek only had 1,064 residents.

The village was remarkably religiously tolerant. There was a sizable community of Quakers, mostly from Pennsylvania, that settled there early on. The spiritualist movements of the early nineteenth century found Battle Creek/Milton welcoming. There was a number of religious followings that emerged during this period, often tied to religious visions; sometimes they were splinter groups of other established religions. The Millerism movement, followers of William Miller, found fertile ground in Battle Creek and in many communities across the country. Miller, a former Baptist minister, had a vision that the Second Advent (coming) of Jesus Christ would happen on October 22, 1844. He had predicted several dates before, but his definitive statement of this date proved to be the undoing of his movement. When October 22 came and went without the end of the world, known as the "Great Disappointment," the followers of Miller found their beliefs wounded beyond recovery. The debacle of the Disappointment in some communities led to mob reaction to the Millerites, including tar and feathering.

The Millerites found a new belief system in the Seventh-Day Adventist movement. Like Millerism, visions played a key tenant with the Adventists, who also believed in living a healthy lifestyle (150 years before it would become trendy). They also believed that the Sabbath was on Saturday as opposed to Sunday. The demise of Millerism brought about a surge for the Adventists.

In Battle Creek/Milton, the first house of worship for the Adventists was built in 1855. Led by James White and his wife, Ellen, the Adventist movement found the tolerant people of Milton/Battle Creek welcoming. By

1855, the Millers had moved to the village and established their first house of worship. The spiritualist movement of the period gave birth to a number of religions, and the citizens seemed more than willing to allow their settlement in the region. The Adventists simply were a larger than normal contingent.

While the Adventists were held together by their religious and health beliefs, they brought with them a massive and popular surge in business, namely printing. They printed their own newspapers and books, all designed to help spread their gospel. Their printing presses provided steady jobs, and Battle Creek became known as one of the largest publishing centers between Buffalo and Chicago, eventually printing millions of copies of books. By the 1880s, Battle Creek's post office would be one of the top three post offices in Michigan due to the amount of books and pamphlets mailed out, spreading the Adventist word.

The western side of town became known as "Advent Town" to the locals. It was said that if you wanted to do banking or purchase of loaf of bread on a Sunday, you had to go to Advent Town, which was shut down on Saturday but open on Sunday. The Seventh-Day Adventists were not seen as any quirkier than the other churches that established themselves in Battle Creek. No doubt their contribution to the local economy with their massive printing business helped make them more tolerable in the eyes of the locals.

Yet the Adventists were "radical" compared to some religions. They argued that women's corsets, commonplace in the era, led to bad health. They claimed that meat was full of toxins, long before the concept of vegetarianism was in vogue. In later years, they would advocate raising women's dress lengths to above the ankles—scandalous at the time. Despite these beliefs, the citizens of Battle Creek warmly accepted them into their community.

The Seventh-Day Adventist Church made Battle Creek its headquarters in its early years. Its dogma of combining both spiritual and physical health would usher in the village's rise in healthcare circles. The Whites would go on to sponsor the education of Dr. John Harvey Kellogg, who would go on to create the impetus for Battle Creek to become the source of the world's breakfast. Their influence would one day carve out the community's perception to the entire world. When the Arnolds arrived in 1858, however, this religious movement was still in its infancy.

The religious tolerance of Milton/Battle Creek mirrored some of the other religious upheavals of the period. One movement that attracted a great deal of support was the drive for prohibition. Michigan adopted a variant of the "Maine Law" in 1853 to ban alcohol sales except for

medicinal purposes. Milton/Battle Creek jumped on the bandwagon the same year, voting 401 to 55 to become a dry city. It was ruled the following year as unconstitutional. Battle Creek's own government attempted to tighten the law, regulating the sales of alcohol, prohibiting its sale in large quantities and banning the sale on Sundays. These laws proved completely unenforceable. Store owners sold whiskey in bulk, drawn from barrels in secretive back rooms. Saloon owners openly operated, even on Sundays. This turmoil between the desire to curtail alcohol sales and the public's desire for its liquor was one that would later factor in strongly in Adam Arnold's life.

When Adam and Maria arrived in Milton/Battle Creek, they would have come in at the Michigan Central Depot. Having lost most of their worldly possessions in the fire in Verona, New York, they likely traveled light. The train arrived three times per day in Battle Creek—morning, late day and midnight. As they stepped off the platform of the station, they would have likely been greeted with a hefty aroma in the air. Cows, pigs and horses roamed the streets, which after a good rain could be knee deep in dark Michigan mud. Battle Creek's sidewalks were often cluttered with "uncouth members of the community." There was no trash pickup in the city. Garbage often piled in backyards and alleys. There was no sewage system other than piping it directly into the river across the street from the depot. Smoke from wood-burning stoves and from the train locomotive itself would have hung in the spring air.

Adam wasted little time in getting settled in with the small community. He purchased the second story of old sash and blind factory of Charles Knight, the father of Andrew Knight. It was located at the rear of the Nichols & Shephard plant, in what was known as the Ward Block, and for some time it had been used as a flour mill. Shortly after his arrival in Michigan, he sent for his brother, Martin, to join him in his new venture. Adam Arnold was determined to enter the pump and pipe manufacturing business.

How he knew anything about the manufacture of wooden pumps and pipes remains a mystery. It is most likely that he bought out Amos Miller, who ran a wooden pump and piping business next door to the building he purchased, given that Miller's business disappears at almost the same time that the Arnold brother's startup opened shop. There's no indication that he had any tradesman experience from his time in New York. The Arnolds were not builders or manufacturers; they were farmers. Arnold liked to tell locals that he had learned the business when he was a boy in France. The only problem with that version of events is that Adam was a toddler when

An 1860s view of a hotel in downtown Battle Creek, a far cry from the sketchy Arnold House. *Courtesy of Heritage Battle Creek.*

An 1860s advertisement for Battle Creek businesses showing Arnold's pump company. *Author's private collection.*

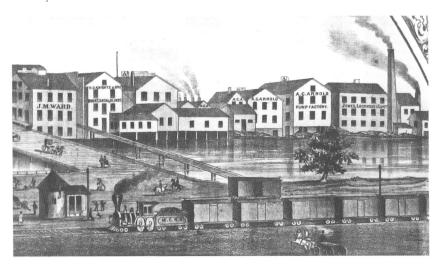

The Arnold Pump Factory, from advertisement. *Author's private collection.*

his family immigrated to the United States. The story helped his reputation, so Arnold stuck with it despite its blatant fiction.

Initially, he and Martin made a good impression with the citizens. According to the 1916 *Battle Creek Enquirer and News*:

Arnold and his brother were both good workmen and made wooden pumps, the first ever manufactured in the city. Their pumps were made of white wood and the pipes that ran down in the well of tamarack and occasionally for an extra job of hickory. Arnold's brother left him and returned to New York, was because of his being a pump maker that Arnold acquired the name of "Pump" Arnold, by which he was universally known for years. After about two years, Arnold bought land on West Canal Street and erected a building for a factory. Arnold lived in a house on the west side of North McCamley [sic] Street adjoining the Michigan Central track, now No. 13 North McCamley Street. In this yard he built a fountain which he connected with his water power in his shop by pipes laid in the bottom of Battle Creek. This was one of the first fountains erected in the city. Arnold afterward lifted on River Street, then on Marshall Street, then at the notorious Arnold House on South Jefferson Avenue that he built and run for years, now the Jefferson.

The power for Pump's audacious fountain came from a hydraulic ram in his shop—no small feat of engineering in 1859. No doubt the fountain served both as a form of advertisement for the Arnold brothers' business and as a status symbol, being the only such fountain in town.

Three years after his settling in the village, the citizens voted for a new charter—a city charter. Several names were submitted to rename the community—including Peninsula City, Battle Creek, Calhoun City, Eureka and Wopokisko (or Waupakisco, depending on the source). The last name in the list was the Indian name for the Battle Creek River, allegedly meaning "river of blood." The interpretation was not uncommon. White settlers interpreted almost all Indian names for rivers to be "river of blood." The New Year's Eve 1858 voting cast two-thirds of the ballots for the name "Battle Creek," and the village was chartered as one of Michigan's cities. The celebration went into the early morning hours, with a big bonfire at the intersection of the two main roads, Jefferson and Main (where modern-day Capital and Michigan Avenues intersect).

No longer a mere frontier village at the fringe of settled Michigan, the city of Battle Creek was growing in both size and prominence. While the new city celebrated its birth, another birth proved devastating to Pump and his wife. Maria became pregnant with their first child in 1858. Named Ada at birth, the Arnolds appeared to be settling in well. Unfortunately, Ada became ill and passed away just before Christmas in 1859. During this period, infant deaths were not uncommon. Tuberculosis, known as consumption, killed

A Beauty Spot along Battle Creek River, Battle Creek, Mich.

A view of the Battle Creek River before the industrialization of the city. *Author's private collection.*

between ten and twenty people annually in Calhoun County. Fevers, as diseases were classified, swept through towns, often killing the youngest and oldest members. Cholera was still prone to outbursts. While Ada's exact demise was never fully determined, it had to have been difficult for the young couple. Adding to the emotional burden, Maria was pregnant with her second child at the time of Ada's death.

On February 18, 1860, George Arnold was born to the couple. A healthy young baby boy helped ease the pain of the loss of Ada for the couple. Little did Pump Arnold realize that George would one day lead to his own downfall in the emerging community.

With the birth of a healthy son, it would seem that Adam Arnold had become a reputable member of the fledgling city of Battle Creek. Unfortunately, that was not the case. Arnold had begun to augment his income by making loans to citizens. Making personal loans was commonplace in the era. Up until the 1950s, pawnshops accounted for nearly 60 percent of personal loans in the United States, and Arnold essentially set himself up as one. Collateral for his loans came in a wide range of forms, be it mortgages or personal items. Watches, the smartphones of the day, were heavily favored, since most had substantial value at the time and were easily resold if the individual defaulted on his payment back to Arnold. Rumors circulated in Battle Creek

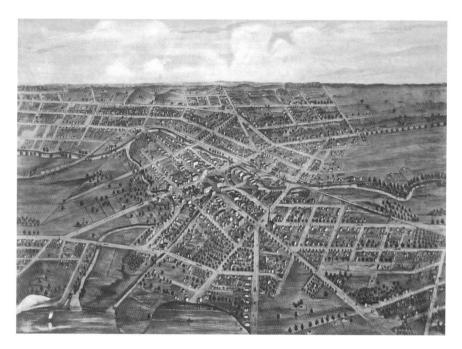

Bird's-eye view of Battle Creek, 1860s. *Author's private collection.*

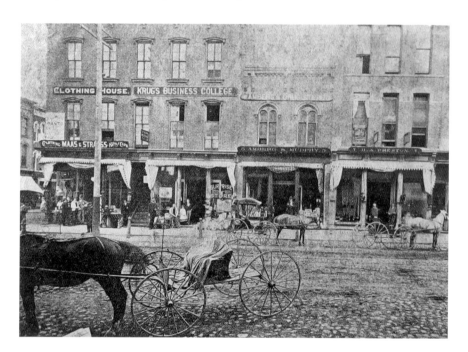

The city's heart: Main Street at Jefferson in 1866. *Courtesy of Heritage Battle Creek.*

that Pump had upward of fifty to seventy-five watches in his possession from those who borrowed money from him.

His rates were exorbitant. "His method was to take a complete bill of sale of every article upon which he loaned the money, and he has charged 50 cents for the use of $1 for one month." Given the high loan rate, going to Pump for money had to have been the last possible option for those who sought him out. This meant that Arnold dealt with some of the seedier characters in Battle Creek. Still, his little side business didn't attract attention until May 24, 1860, when his enforcement of a loan caught citywide attention.

Sam Wardell of Battle Creek had only been in the city for a year, working as a clerk at a local boardinghouse run by Edwin Morse, when he apparently borrowed money from Pump Arnold. Both men were alleged to have been associated with an unnamed female. The limited documentation from the period does not specify the relationship the men had with the woman. Per the *Detroit Free Press*, "It seems that these parties were frequents at the residence of a woman whose reputation is none of the best, engendering there upon between them a rivalry which naturally brought about this result." The hint of the woman's reputation was a polite way of implying that she was a prostitute, which certainly would have raised eyebrows.

While a woman may have sparked the incident, it was a financial issue (Wardell being unable to pay back his loan) that triggered a violent response from Arnold. The act was considered so heinous that it was covered in the Detroit newspapers, a testimony to the cruelty of Pump Arnold.

How Arnold enforced his loans suddenly became a matter of public record:

> *Dastardly Act! On Saturday night last, as Sam'l Wardell, a peaceable and quiet inhabitant of this city was going to his boarding place, he was brutally assaulted by a party of ruffians, and a mixture composed of tar and sulphuric acid, thrown into his face and upon his person. It is supposed that the designs of the villains were, first to put out his eyes, and then to finish their revenge by beating him. Four men have been arrested, one of whom gave bail; the other three are now confined in the city jail. A.C. Arnold is supposed to be the instigator of this plot, and if so, the punishment which the law inflicts upon such persons is none too severe for him.*

Other newspapers referred to the caustic solution thrown in the face of Wardell as "Blue Vitriol." All accounts indicated that the man's face was badly disfigured by the horrific assault. One thing was clear: Arnold had escalated his criminal activities from arson to loan sharking.

Wardell did not cower in fear from his assault. Despite being partially blinded and physically deformed in the assault, he went after Pump with a lawsuit, suing him for the damage done to his face and eyesight in the attack. Arnold went to court and lost, suffering a $6,000 charge for his role in organizing the attack on Wardell (more than $155,000 in today's money.) Wardell never collected a penny, however. Arnold had caught wind that the lawsuit was being filed and had transferred all of his property, the business and everything he owned into his wife Maria's ownership. While Wardell won in court, Arnold claimed that he was penniless, and at the time, the Michigan courts were unable to tap Maria's newfound wealth. Wardell's moral victory was little more than an expense for him, as Pump escaped by claiming bankruptcy and paying Wardell mere pennies on the dollar.

Shortly after the lawsuit, Martin Arnold, Pump's brother and partner, left the business and returned to Oneida County. One can only surmise that Martin wanted little to do with his brother's business dealings. The pump business was, by public accounts, quite prosperous, so it had to have taken a lot to walk away from that and return to New York.

THE ARNOLD HOUSE

After a time Arnold erected on South Jefferson Street, adjoining the C & GT
depot and opened a hotel now called the Watkins's house. Here it was that a great
many evil deeds were done, and the name Arnold Hotel became a synonym for all
that was bad. It was while here that his son George formed his habit for drinking
that led to his ruination.
—Battle Creek Moon, *"In Jail! Charged with Murder is A.C. Arnold,*
Charged with the Murder of His Son," February 8, 1895

With the birth of his son, the establishment of a reputable and profitable business in the new city and the very public association with the horrific act of throwing acid in a man's face, it might have been enough to give a man pause. It seems that it did for Pump Arnold, at least at the start of the 1860s. While the state and nation girded its loins for battle in the Civil War, Arnold's focus was on growing his business. For a short time, it appeared that he was leaning away from criminal enterprise.

While the citizens hung on every snippet of news from the war, Arnold turned his focus to making money. In 1862, he set up a public bathing room next door to his pump factory. Bathhouses were commonplace in the city in an era where indoor plumbing was all but unheard of. For men, they were often much like fraternal organizations—a place to gather, exchange information and broker deals. With the bathhouses filled with hot water and the hefty aroma of cigar smoke, Arnold was able to turn a good profit from his enterprise.

Battle Creek was growing in the post–Civil War period. In 1860, the population of the new city had been 3,509. It had boomed by 66 percent in just ten years, reaching 5,838. More importantly, Battle Creek was emerging as an industrial city. Small shops were disappearing, while others changed into new production companies, including Adams & Smith, manufacturers of carriages, buggies, wagons and sleighs; Kellogg's Flouring Mills; and Jones, Lockwood & Lunt door and sash works, which replaced the lone blacksmith. Water power and emerging steam power were beginning to change the nature of the community.

After the end of the war, Pump expanded his business. In 1870, he added two additional buildings to his wood pump-works. One of these involved the installation of an expensive planing mill. This was no small endeavor. The equipment had to be purchased in New York and shipped to Battle Creek at a considerable cost (well over $3,000 at the time). According to newspaper advertisements he took out at the time, his planing mill was "the largest in the city," able to handle boards up to four inches thick. Robert's *Pioneer Days* ran one of Arnold's advertisements for the period: "A.C. Arnold— Wholesale and retail dealer and manufacture of wood-pumps and water pipe, also an assortment of iron force, list and suction pumps, well buckets, windlasses, hydraulic rams, fountains, fountain sets, lead pipes, wood pipes of all sizes, hoisting apparatus, estimates, plans, and specifications furnished." With three buildings for his pump business and a bathhouse, Arnold was a dominating presence along the millrace in downtown Battle Creek.

In 1873, Pump sold his downtown business to Milton K. Gregory, a Goguac prairie farmer. Pump's timing for getting out of the business was uncanny. On August 17, 1873, Arnold's former pump business burned to the ground in what was described in the *Battle Creek Journal* as "the most extensive fire that has visited our city in several years, which caused great apprehension among our citizens." The fire began at 10:00 p.m. next door to the pump business, in Case's Window Shade factory on West Canal Street. Oils were used to color the shades in the little factory, and the rags soaked in the oils caught on fire. Mr. Case tried to stop the blaze, but the flames lapped their way to large bins filled with the oils. There was a flash, and the entire structure went up in flames, spreading to the pump-works and Burch's blacksmith shop, John Slade's wagon works and Merritt's & Kellogg's shop, engulfing the wooden structures and their inventories. While not listed among the victims, it is safe to assume that Arnold's Bath House was one of the structures lost since it disappeared from references in records starting that year. A volunteer fire force arrived, but by the time their steam

pump had built up enough pressure to shoot water at the flames, it was already out of control.

Gregory and the other businesses did not have insurance, which was not uncommon in the period. Insurance was a luxurious expense, and fires often swept the early structures into a blazing conflagration in a matter of minutes. Large fires that consumed blocks of Battle Creek happened almost every other year and would until the 1890s, when piped water and an organized fire department brought such fiery disasters to bay.

In many respects, Arnold's shift from manufacturing was fortuitous. Immigrants were still pouring through Battle Creek every day, and most of them carried gold as a universal spending currency. Rail traffic more than doubled when the Chicago & Lake Huron (later known as the Grand Trunk and Western) Railroad also opted to run through the city. The addition of its rail station downtown provided a large influx of potential customers. Most were of Scandinavian and German origin, with many barely speaking English. The railroads stopped in Battle Creek to take on water and wood. Most were not planning on settling in the area but were on their way west.

For Pump Arnold, they were easy marks whom he hoped to part from their precious money. His first dabbling in the hotel industry came in 1874. He invested in a hotel that he leased to L.F. Bowen. Named the Clifton House, it touted a four-hundred-barrel cistern and seven rooms on the second floor. The first floor had an office, a kitchen dining room (which doubled as a saloon) and a single bedroom. On the south side of the building was an Eagle windmill, which powered a force pump to provide the business with water. Pump bragged that he was contemplating putting one of his custom fountains on the north side of the hotel, but that was more promise than reality. The hotel was built on South Jefferson Street, not far from the new Chicago & Land Huron station. Arnold was a sharp study with this first investment. The cash was not in renting the rooms directly—it was in the saloon. Trains that came into the station to refuel and re-water had riders who would come for a quick drink at the hotel.

The following year, Arnold opened his own hotel, named the Arnold House. In its history, the hotel would bear a lot of different names—the Alhambra, the Bellvedere, the Watson House, the Exchange Hotel and others—but in Battle Creek lore, it would always be remembered as the Arnold House. He chose a good location, building adjacent to the new train station. Pump saw to it that the entire first floor was a large saloon, complete with a piano that he had his son, George, play.

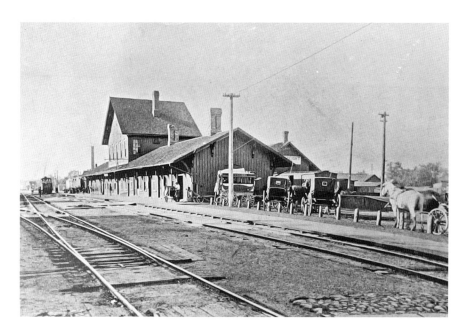

The original Grand Trunk passenger station in Battle Creek. This view is almost how it would have appeared from the Arnold House. *Courtesy of Heritage Battle Creek.*

Clifton Hotel on Jefferson Street. *Courtesy of Heritage Battle Creek.*

Pump saw the railroad station as an income stream. As the *Battle Creek Moon Journal* would note fifty years later, "In those early times trainloads of immigrants were to be seen passing through the city seeking homes and fortune in the west, and among some of the wild stories concerning the Arnold House were those dealing with these self-same immigrants."

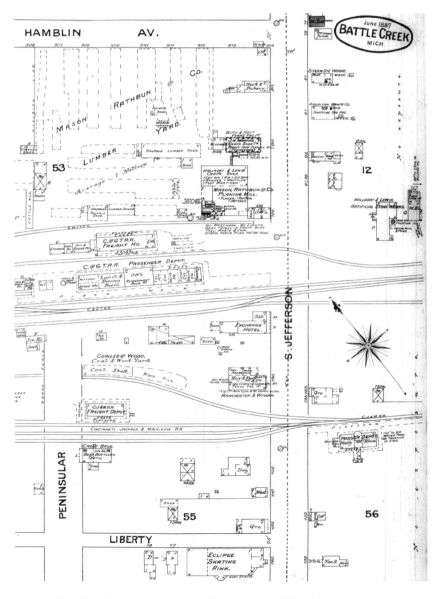

Sanborn Fire Map showing the Exchange Hotel. *Courtesy of Willard Library, Battle Creek.*

"Arnold got together a considerable fortune," said a citizen who remembered him well, "and no small part of it, I fancy, came through this source. The immigrant trains would stop at the little old frame station house and immigrant men would hurry up the track to the Arnold house to get a drink. They would have gold, for gold was plentiful then, and their money would be of large denomination so it would be an excuse for Arnold to have trouble in making change and the engine would whistle, the train begin to move, and the poor dupes would have to make a dash to catch on, leaving in the Arnold till their good money…There were other rumors now and then heard concern peculiar and far from law abiding carryings-on in the place, but nothing was ever definitely known about such."

Pump was not satisfied with just taking money from the men who hurried over for a quick drink. He surmised that he was missing out on those immigrants who remained on the train. Rather than lose that income, Arnold merely expanded his scam. Arnold would prepare sandwiches and small bags of popcorn to sell to them. According to the stories of his nefarious practices, Pump would take a large bill with him—in some accounts a $1,000 bill (although in reality it was likely a $100 or $20 bill). As local Battle Creek historian Bernice Bryant Lowe put it, "We can bank on it that Pump, himself not to be trusted, would never have a real $1,000 available to pickpockets—it would surely have been counterfeit."

When the train pulled into the station, Pump would climb aboard the passenger cars and offer to sell the snacks to the hungry travelers. The immigrants were often unfamiliar with the coinage and dollar values, which made them the perfect targets for Pump's scam. They would offer him dollars or gold coins, and Arnold would dig into his pocket to pull out his large-value bill. He would give them their food and tell them, "I have used all my change for this. I'll have to go get some more." Arnold would gather their money, hand out their snacks and then leave with a promise to return with change. The train would depart, leaving the passengers out their money with no opportunity to get off and track down the rascally Arnold.

Pump's activities were well known in the city, but it seemed to be a victimless crime. No criminal charges were leveled at him, mostly because his victims were whisked out of the city via train. While his thefts were despicable, the city was not inclined to take action. The railroad, however, felt quite differently about the theft of its passengers. If word got out of Pump's actions, it could discourage passengers from traveling their line. Their solution was eloquent and simple. In 1888, a tall wooden fence was erected along the border of the train station to hide from passengers a sight

line to the Arnold House to trim Arnold's supply of clients. The solution worked, and Pump didn't fight it. Instead, he put up signs visible from the passenger platform to lure in thirsty immigrants.

Running the Arnold House was a learning exercise for the crafty Pump. He recognized the changing market in Battle Creek. Consumer goods were growing in popularity as the industrial age was beginning in the nation. As people became more prosperous, they wanted things to make their lives easier or provide them entertainment. Getting those goods was often an arduous activity taking months to order via the mail. Pump saw a market and immediately began to step in to fill the gap. According to one newspaper account, "Arnold engaged in speculation, buying and selling pianos, organs, sewing machines and other articles of merchandise. It is claimed that he had a scheme for avoiding payment on these articles, and that the parties whom he dealt with were cheated out of their money." Arnold actually opened what was called the A.C. Arnold Piano Factory, which was really just an assembly factory/store for pianos. The pianos were manufactured in parts and shipped to Battle Creek, where Pump would oversee their assembly. Under the guise of a reputable business, Pump was once more falling into a pattern of illegal and unethical behavior.

Pump's reputation in the city was becoming more cemented over time. In a community that favored modesty, Arnold flaunted his wealth. He had an expensive black carriage in which he was driven around town by a chauffeur. Arnold was known to wear silk pajamas, the reference of which in the local newspapers was seen as almost scandalous at the time. Pump had somehow obtained printed but uncut/uncirculated ten-dollar bills, which he folded and liked to show others, implying he had connections with the U.S. Mint. The only man with a fountain in his yard seemed bent on making sure that his neighbors saw him as a man of wealth and prestige, despite some of the unsavory activities such as the acid attack on Sam Wardell.

Maria Arnold also developed a reputation in the city at this time, although it was the antithesis of her husband's. Maria took in wayward or abandoned youths. Two of these were "adopted" by the Arnolds. One was Grace Eschbaugh, a young mulatto girl whose father, Uriah, had been arrested for burglary and sent to the state prison in Jackson, Michigan. Rather than let the child be raised in an orphanage, Maria took her in as her own daughter. Another wayward soul was a young boy, Fred McDonald. The homely boy became a "man Friday" for Pump, handing everything from housekeeping to Pump's books. Both of these foster children remained out of the newspapers, with the exception of Grace, who received notice in 1878 for not missing a

single day of school. In almost all respects, Maria and Pump were more successful with other people's children than they would be with their own child, George.

George Arnold was brought up at the Arnold House. Like any family business, George was an integral part of operations, tending bar, working as a clerk, playing piano and attending customers. In the case of George, it was also his first exposure to drinking. His drinking would dominate his reputation in the community and ultimately contribute to his death. George's consumption of alcohol was noted in his later years, indicating that it started in his youth. Sadly, working at a bar only served to solidify the grasp of liquor on his life. Whereas Pump abstained from drinking, George consumed enough for both of them.

The old adage of sending sons off to military schools to improve their behavior seemed to apply with Pump's only son. It is most likely that the Arnolds saw George's drinking as uncontrollable and hoped that military school might help straighten the youth out. Pump's solution was to send George to the Highland Military Academy in Worcester, Massachusetts. The school had been founded in 1856, just before the Civil War. Attending such a school was an expensive endeavor, and having a son there, especially on the heels of the Civil War, would have been a mark of high society in Battle Creek.

George attended the academy from 1875 to 1877. His performance was anything but stellar. Unlike most of the first-year cadets, young George did not receive a promotion. In December 1875, he came back home for the Christmas holidays, and the newspaper noted that George had put on forty pounds. He did not graduate from Highland but rather was mysteriously withdrawn from classes there, most likely due to low grades.

The solution the family sought out was to place George in one of the first classes at the Michigan Military Academy at Orchard Lake. He left with Frank Upton on September 18, 1977, followed one day later by Fred Clark. There was a strange air of urgency with the decision. It was made on Monday, and George was on a train heading toward Detroit the following day.

The Michigan Military Academy had been dubbed the "West Point of the West." The brainchild of Captain Joseph Sumner Rogers, it was based out of the palatial three-storied, red brick home of state Supreme Court justice (and former Civil War general) Joseph Tarr Copeland on the shores of Orchard Lake. The home was a dominating feature on the lake, with two large towers and corbelled cornices. The home had a castle-like appearance,

The Michigan Military Academy on Orchard Lake, where George went to school. *U.S. National Archives.*

and the lake was a popular camping locale for people seeking to get away from the bustle of Detroit in the summers.

The Michigan Military Academy opened its doors in 1877, and George Arnold was in the first class to attend the institution. That first class was small, only forty-three students. Attending the academy offered great benefits. Graduates would have their entrance examinations waived at the University of Michigan and Cornell University. The federal government recognized the new institution, and there were high hopes that West Point might one day recognize the school, much like the Virginia Military Institute, as a preparatory school. Military icons such as William Tecumseh Sherman, general in chief of the U.S. Army, came to the school as guests and speakers. Later classes would see classmates as renowned as Edgar Rice Burroughs, the author of the *Tarzan* books, and John C. Lodge, future mayor of Detroit. Young cadets seemed to have a leg up on their peers in the state, not to mention the honor of being in the first class taught at the school. George's attendance was something that could have laid a strong foundation for his future aspirations.

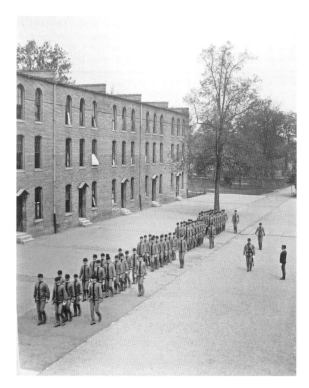

Left: At the Michigan Military Academy. George Arnold is likely in this photo of the first class on parade. *U.S. National Archives.*

Below: The Michigan Military Academy. George is likely in this image as well. *U.S. National Archives.*

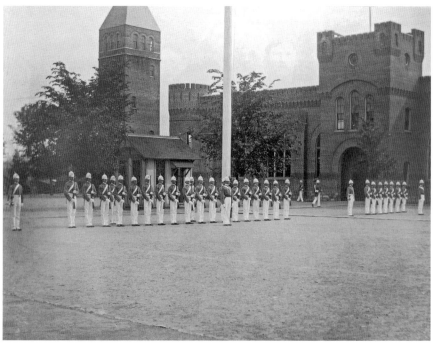

Class at the Michigan Military Academy during the time that George Arnold attended. *U.S. National Archives.*

The detailed records of George Arnold's performance at the Michigan Military Academy have been lost to time. The frequency of expulsion of students was said to be very high, although statistics no longer exist. One thing is for sure: the carefree George Arnold did not remain at the academy. On Christmas Eve 1877, George returned home from the MMA and never returned.

Gone was the hope of George Arnold attending the University of Michigan or pursuing a career in the military. Gone was the prestige of Pump's son being in the first class of graduates from the new institution. Gone was the thought of George being an independent man. From this point forward, he was destined to be tied to both his father and his father's nefarious businesses. Lost in all of this was the spirit of George Arnold and the respect of his father.

THE CON MAN

The conspiracy alleged was one between Adam C. Arnold, John Snediker, and other persons unknown. As developed in the evidence, the conspiracy contemplated that John Snediker should dress himself to represent Arnold, take certain bank drafts owned by Arnold and payable to his order, negotiate and indorse them in Arnold's name, divide the avails with Arnold, and then Arnold should stop payment and demand and obtain new drafts instead.
–The People v. Adam C. Arnold, *Supreme Court of Michigan, 1882*

Any effort to record the history of Pump and George Arnold starting in 1878 is clouded with a mix of alcohol and violence. The newspapers of the time covered snippets of the sordid details of both father and son. While the *Battle Creek Daily Journal* tended to be a more business-related newspaper, the *Moon Journal* (aka the *Daily Moon*, the *Battle Creek Moon*, the *Nightly Moon* and so on) was far more scandalous. The *Moon*'s "Moonbeams" section often dealt with every little court proceeding, often passing judgment on those arrested or in court before the trial.

Pump's ownership of the Arnold House was destined to expose George to two things—shady characters and alcohol—a combination that was destined to lead to trouble. Some instances were minor but quite public, mostly thanks to the *Moon*'s coverage. For example, on March 13, 1878, George had Philip Woolcott arrested for breaking into the chicken coop. Woolcott had been drinking and had been nabbed attempting to steal a hen, although he denied it, despite the fight that he and George got into during his apprehension.

The first glimpse the general public got of the inner workings of the relationship between Pump and his son came in August 1878. It was a typical hot, humid Michigan summer, and George Arnold, in his teens, got drunk and was involved in a brawl with his father. What made this donnybrook different was that George went to the courts and swore out a complaint against Pump. Justice Rowe indicated that the matter would go before a jury in the following week, but after he sobered up, George recanted his complaint. The matter made the newspapers and aired George and Pump's strife in a very public forum, offering little doubt that this was an indication of greater problems at home. Little did either man realize that this was just the first of many trips to court for their fracases or that it might one day cost George his life.

George's temper was not limited to his father. His mother's brother, Ira Daggert (also seen as "Daggart"), came to visit the family in Battle Creek in May/June 1879. As the *Battle Creek Daily Journal* reported on June 3, "A little 'unpleasantness' arose between George Arnold and Uncle Ira in front of the Arnold House Monday evening and in the scuffle Arnold in some way fell under the wheels of a passing lumber wagon and was run over. His left ankle was dislocated and both bones of the left leg broken between knee and ankle. Dr. Cox reduced the fracture." Daggert filed charges against George for the altercation but dropped them—most likely at the prodding of his sister and George's mother, Maria. Again, the Arnolds found the inner dysfunction of their family's inner turmoil played out in the newspaper for everyone to see.

The Arnold House itself tended to bring in some of the lower elements of Battle Creek's society. Worse, the staff of the Arnold House only seemed to add to the legal hassles of the Arnold clan. Maria, Pump's wife, filed charges in May against Clark Frazzier. He had apparently embezzled an undisclosed amount of money and stolen a gold watch and chain. The matter was settled with a substantial fine and a stint in the Calhoun County Jail.

Because the Arnold House was an inexpensive hotel right across from the railroad station, it drew in more unsavory characters. For example, on July 29, 1879, Sheriff Gustavus M. Gates of Kalamazoo send a telegraph to Pump as proprietor of the Arnold House: "An old lady giving her name as Eveline Russell, claiming to have lived with you, is arrested for larceny. She ought to be sent to her friends. What do you know about her?" Arnold was familiar with Miss Russell. She had been a resident at the Arnold House months earlier. As a testimony to the types of clientele that the Arnold House attracted, Russell had become a panhandler in the city, creating "false sympathy among our citizen by complaint of her treatment there." Where

Sheriff Gates had hoped to send Miss Russell back to Battle Creek, Pump bluntly refused to take delivery.

Rumors of prostitution at the Arnold House were beginning to circulate in the social circles of Battle Creek society. Prostitution was a problem in Battle Creek starting in the year of the city's founding, 1859. Before 1859, there were only laws on the books from the State of Michigan regarding prostitution, and those were rather vague, defining a prostitute, a "common prostitute" and a "keeper of a house of prostitution." The fines were minimal. Battle Creek, however, was a religious community and sought to try and squash the peddling of human flesh. The Common Council of the City passed a sweeping series of ordinances dealing with prostitution. Anyone running "a house of ill fame and assignation" could be fined $25 to $100 with up to ninety days of jail time. A person letting out (renting) a house used for such purposes faced the same punishment. Any individual who remained in such a house for the purposes of "prostitution and general debauchery" could be fined no more than $50 and face thirty days in jail. These ordinances put men like Pump Arnold responsible for what happened in the businesses they owned.

Prostitution and adultery was not all going on at the Arnold House; outright robbery was also relatively common. For example, in May 1880, Giles Fitch had his wallet, money and watch taken from him by a small band of highwaymen. There was no trace of this small band of robbers, and Fitch did not know how they knew he was carrying money, although it makes one wonder if Pump himself may have been behind the robbery.

What was beginning to emerge in the minds of the citizens was that the Arnold House was becoming a den of criminal activity. In fact, when one looks for articles relating to crimes at other hotels of the period in Battle Creek, the other establishments are rarely mentioned. At the same time, the police were constantly drawn to the Arnold House. If there were public outcries for Pump to clean up the hotel, they didn't make the newspapers of the era. If such dissent were voiced, it was clear that Arnold simply ignored them.

Those who crossed Pump on financial transactions found that he was more than willing to use force to secure what he was owed. In March 1880, Harry S. Bell, a Battle Creek township schoolteacher, ran up a large number of IOUs throughout the city. When Bell came to Battle Creek, he took a long-term room at the Arnold House. Not only did he owe Pump money, but he also hired a horse from Arnold "and in other ways got into debt, and discharged the greater part of it, but left about $11 unpaid." He showed

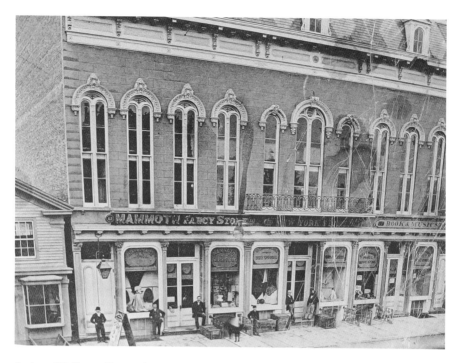

A view of Jefferson Street, the commercial hub of Battle Creek, circa 1880–85. *Courtesy of Heritage Battle Creek.*

Pump a promissory note signed by two directors of the district calling for sixty-five dollars, and if he would cash it, he would pay off Pump. Arnold wanted his money owed and didn't question the authenticity of the note. Bell stuck him with the note, heading off supposedly to London, Canada, which was his home. Three months later, Bell was spotted in town by Arnold, who physically apprehended him. The two got into a scuffle on Jefferson Street in broad daylight, and Bell, realizing that Arnold was not a forgiving character, fled on foot from Battle Creek.

Pump Arnold wasn't satisfied with small transactions to make money. In March 1880, Arnold concocted a scheme to score big—about $40,000 in modern money. He began to plot out a complicated scam designed to take a bank's money through fraud. As with most conspiracies, however, word of the con job got out before its bungled execution.

Just prior to Valentine's Day 1880, George Rogers, a Battle Creek constable and detective, received a tip that Arnold would be meeting with his co-conspirators along the riverbank behind the Arnold House. The informant was Samuel Snediker—the actual conspirator in the case—who

had apparently gotten cold feet regarding his intended role. Valentine's Day was on a Saturday night, and Rogers had been told by Sam Snediker the exact location of Arnold's planned meeting. The constable secreted two of his men, Martin E. Brown and James H. Scott, to hide themselves along the bank of the Kalamazoo River in the thick bushes—hoping that they would be able to overhear Arnold. Their efforts were met with success. Pump Arnold appeared along with Sam Snediker, and on a bench along the river, Arnold began to lay out his scheme. Sam Snediker was hard of hearing, so he spoke loudly and required Arnold to do the same, making it easy for Rogers to overhear every detail of the plan.

Sam Snediker was a shady individual, just like Pump in many respects. A frequent patron of the Arnold House, he had been arrested several times for drinking and brawling. He had a reputation in town for being unreliable and talkative, which makes it more surprising that Pump would consider him for such a risky and high-profile scam.

The scheme, as Pump laid it out, was that he was in possession of $1,900 in bank drafts, a promissory note payable by the bank to him personally. These were from a New York metropolitan bank. Arnold would provide the drafts to Sam Snediker along with a set of his clothing and his watch. Snediker appeared to be physically similar to Pump in terms of face and stature. Snedicker, posing as Arnold, would then travel to another city and would cash the drafts with the purchase of lumber, since lumber mills were accustomed to handling drafts for large purchases. Snediker was to send $1,400 back to Arnold and keep $500 for himself. Once Pump received the cash, he planned on telegraphing the originating bank in New York that the drafts they had issued him had been stolen. He would demand that the bank put a hold on the original drafts and issue him new drafts as replacements.

A scam of this type was only as strong as its weakest link, and in this case, it was Samuel Snediker, both for Pump and Constable Rogers. Rogers conferred with the county prosecutor, who felt that it was best to have Rogers monitor the con job but to allow it to go on, closing their trap after Arnold had committed the fraud. Such a plan would ensure Pump's prosecution. As such, Snediker traveled to Grand Rapids, dressed as Pump Arnold, and fully planned on executing the crime as Pump had laid it out. Sam Snediker, however, lost his nerve again. Rather than admit to Arnold or Rogers that he had chickened out, Sam contacted his brother, John, who lived in Calhoun County. John, he felt, might also pass for Pump, and he provided John with Arnold's coat, suit, plug hat and watch. Pump was apparently unaware that Sam had outsourced his role in the scheme.

John Snediker proved no more or less reliable than his brother. John was told by Sam to go to Greenville to find a lumber company, but John misread the train schedule and ended up on a train to Centreville, Michigan, instead. With no lumber available to purchase there, he attempted to improvise the plan and use the notes to purchase wheat, but that ploy failed miserably. By all accounts, his judgment was impaired because of a copious amount of alcohol, most likely to give him the nerve to even attempt the scam. John Snediker tried his best to pass himself off as Arnold, flaunting money and telling people who he was. When he went to a bank, the Snediker propensity to fold under pressure emerged as a genetic trait. At the First National Bank of Sturgis, John Snediker didn't attempt to cash all of the drafts, instead opting to cash only fifty dollars worth, perhaps just to see if the fraud would work. It failed miserably. His performance as Pump Arnold at the bank was so unconvincing that the cashier, John J. Beck, sent for the marshal.

Marshal H. Hinckley of Sturgis arrested John Snediker, and when he heard his story of being Adam Arnold of Battle Creek, the marshal decided to call his bluff. He sent a telegram to the Battle Creek constables saying that the man representing himself as Arnold had in his possession $1,900 in drafts he was trying to dispose of; he lamented that the man appeared to be crazy and was "throwing money around promiscuously, and that he thought the party should be taken care of."

The jig was up. Battle Creek sent a telegram back that Arnold had been seen in the city that day. Constable Rogers stepped forward with his information of Arnold's plotting along the riverbank and a warrant was issued in St. Joseph County for Pump's arrest. Initially, Arnold was held on a $1,000 bond, and it was thought that he might remain in jail for some time. Pump leveraged his connections in the city to pay for his release. In a few days' time, John Helmer and Ralph Cummings paid for Arnold's release using some of his real estate for collateral.

On March 27, Cummings and attorney Frank W. Clapp escorted Arnold from St. Joseph County back to Battle Creek. Rather than hide in shame and prepare his defense, he beat a path directly to the *Battle Creek Daily Journal* to being to spin his version of events for the public. Pump bragged about his incarceration to the editors. Of Marshal Hinckley, he said that the marshal had "used him in a very generous, liberal manner, allowing him almost as much liberty of action as though he had been a guest." He reported the hotel there as having "a fraternal feeling for him upon the ground of him being a landlord, and says they gave him special reduced rates."

Arnold claimed that his arrest was the result of an old grudge on the part of "persecutors of long standing." Pump claimed that a similar affair occurred years ago and that it was a failure as well but failed to specify any of the details. He was sure that "the present prosecution will likewise fail for want of grounds to base the charges upon."

The Battle Creek press did not seem to care about the Snedikers—their focus was almost entirely focused on Pump. The press focused on Arnold as the mastermind of the entire scam. Indeed, it is clear that of the three men involved, Arnold was the smartest. Part of the emphasis in the newspapers on Arnold was that he was the most publicly known of the accused—the Snedikers were small-time criminals. Arnold possessed a reputation.

The sensational nature of the case was covered as far away as Detroit, mostly since such fraud crimes were a rarity. As proof of this, a stranger wandered into the Sturgis Hotel claiming to be A.C. Arnold. When the clerk turned his back for a moment, the fake Arnold grabbed the contents of the money drawer and "jumped the town" before the marshal could be summoned.

On April 7, 1880, the Arnold case was brought to trial in a packed St. Joseph County courthouse. The prosecution started with constable George Rogers and his witnesses who had overheard the plan that Arnold and Sam Snediker had laid out within their earshot. Arnold was defended by some of Battle Creek's model citizens, L.D. Dibble and Frank Clapp, who extensively cross-examined Rogers and his witnesses "with vigor."

On the second day of the trial, Henry Potter was called to the stand. Potter saw Arnold go into the barn in the rear of the Arnold House with Samuel Snediker, and after a short period of time, Snediker "emerged having on a suit of clothes entirely different from the ones he wore when he went into the barn." Potter further testified that he had seen Snediker at the Michigan Central train station and conversed with him there briefly. He noted that the clothing was recognized by Potter as belonging to Arnold. Snediker confided to Potter that he was catching a train to Grand Rapids, solidifying the testimony of Rogers as to the fundamentals of the conspiracy. Bank cashier John Beck testified as to John Snediker's bumbling attempt to cash the fifty-dollar draft.

Pump granted an interview to the *Battle Creek Daily Journal* and gave a glimpse of what his defense might be. He claimed that the Snedikers had been working up the scheme for three months. They were working with other individuals as part of a ploy to entrap him. He further insinuated that John Snediker must have stolen the drafts from him. Arnold said that his safe was locked but that he had lost the key for three weeks and

was unable to state whether some of the genuine drafts that had been deposited were missing or not. He refused to sign out a complaint against John Snediker, but it was clear that the defense was turning into an "every man for himself," situation.

While Arnold tried to sway the press with one version of events, Dibble and Clapp came at the case from an entirely different angle. They filed charges of forgery against John Snediker, charging him with forging Pump's name on the draft. They mounted a vigorous defense of Pump, selling out the Snedikers at every opportunity.

The prosecution took the uncashed $1,850 drafts and gave them to a local man, a Dr. Eastman, who had secured them in his safe. Arnold's attorneys argued that the drafts should be returned to Arnold since they were made out to him. In a legal twist aimed at putting pressure on the community and prosecution, the Arnold defense team filed suit against Dr. Eastman, an innocent bystander in this process, charging that he was illegally holding the drafts. This caused quite a bit of tension in the community and forced prosecutors to the table. Dibble and Clapp agreed that Arnold would repay the bank the fifty dollars and provide ten dollars to Dr. Eastman for his trouble. The civic-minded Eastman refused, since he had been told to hold the drafts until the conclusion of the trial. In response, Dibble drew up paperwork charging him with embezzlement. To the citizens of St. Joseph County, it was becoming clear that ending this case quickly would be the best for all parties involved.

In early May, the efforts of Arnold's defense team paid off. The charge of larceny of the drafts against John Snediker, as raised by Arnold's defense team, was dismissed. The prosecution's charge of defrauding the bank against Arnold and John Snediker was also dismissed. Arnold and his legal team agreed to drop his lawsuit against Dr. Eastman. The charges of conspiracy to defraud against Arnold and the Snedikers were upheld, however, and the men were found guilty. The defense team tried to get the charges dropped since there was no evidence that Arnold had met with Snediker at all, but the judge did not buy the argument.

Arnold's legal team immediately filed for appeal to the Michigan Supreme Court. It filed on two accounts. One was that Arnold had not been tried in the jurisdiction where the crime was charged—the conspiracy having taken place in Calhoun, not St. Joseph County. Second, they contended that Arnold had never been in conspiracy with John Snediker. All testimony had pointed to Pump conspiring with Sam Snediker, but there was no evidence that linked Pump to John. It took the better part of a year for the Michigan

Supreme Court to weigh in. It tossed out the first argument, given that the charges had been filed in St. Joseph as part of the execution of the fraud. On the second part, it sided with Arnold's defenders and set aside his conviction.

Pump Arnold had beaten the odds and had escaped the grip of justice. Almost to add insult to injury, in April 1882 the Honorable L.D. Dibble was forced to file suit against Pump for failure to pay the legal fees that had been racked up in his defense. George Rogers's house was burned to the ground, the result of arson. Rogers made it well known that he felt that Arnold was responsible, as revenge for the case.

While the Arnold family had been the subject of a very public legal matter, one calling into question Pump's integrity (or solidifying it, in the eyes of many), it was far from the end of their legal issues. In late March 1881, the focus shifted from Pump to his son, George, and in a manner that was more horrifying.

On the night of March 27, 1881, George Arnold had once more tipped far too many bottles and was intoxicated. He had been arrested just the day before for being drunk in public, so it seemed to be a twisted, drunken spiral for George. At about 11:00 p.m., George got into a quarrel with Angus McDonald. McDonald was a switchman at the Grand Trunk Depot, across from the Arnold House hotel. The two men had a long-standing feud between them, but on this evening, it turned to violence. McDonald had thrown Arnold out of the switch house, telling him to go home. George went over to the Arnold House, secured a large knife (or dirk) and went back to the depot. While McDonald was working, George crept up behind him and attacked him, slashing away wildly with the deadly blade.

McDonald was stabbed in the back of the head, and when he spun around and tried to fend off the assault, he was cut in the face and on his hand. George, realizing what he had done, fled, heading out of the city. McDonald was badly injured. Dr. White, who dressed his cuts, said that the wounds were "very dangerous."

George Arnold panicked and fled Battle Creek rather than face possible prosecution for attempted murder. Angus McDonald recovered, but the legal fate of George Arnold hung up in the air. The press certainly felt that the younger Arnold should be brought up on charges, and that was enough to keep him away from the city.

Adding to their nightmares, the Arnolds once more were forced to deal with another wave of legal issues when Pump's operations were raided by revenue agents. As reported in the *Battle Creek Nightly Moon* on April 9, 1881, one of Pump's schemes involving liquor had been busted. There had been

suspicion for some time that Adam Arnold was selling liquor illegally, under the guise of "hard cider" and "Rock and Rye."

After months of hard work gathering evidence, they went after Pump with a raid on the Arnold House and a storage facility that he maintained in Detroit. What they found was seventy-two gallons of illegal liquor, doctored by Pump for resale:

> *His scheme was to buy the whiskey, put rock candy in it and sell it as "Rock and Rye," as a patent medicine, when it was almost pure whiskey. Then by putting quantities of hard cider into it, the entire liquid could be sold for cider. It has been a well-known fact for a long time that Arnold's hard cider was worse than whisky to get men drunk, and the officers have had more trouble for drunkards form his place of business than from the saloons. The temperance people have tried time after time to get some evidence whereby they could convict him of the illegal sale of liquor, but they could not...His son George is now a wanderer from home and dare not return fearing arrest on a charge of attempted murder. The Snedeker-Arnold [sic] conspiracy case has hung over his head for the past year.*

This time it was not Pump who leapt to the defense of his honor but rather his usually meek wife, Maria. She wrote to the editor of the *Nightly Moon* with a page-one editorial letter defending her husband and son:

> *"Let Us Alone"*
> *Editor*—Nightly Moon*:*
>
> *Dear sir: It seems to me that your severe attack on Mr. Arnold in Saturday's paper is uncalled for, and some of your statements are founded upon facts which I very much doubt. It is undecidedly cruel, both to him and myself. Mr. Arnold has been a patron of yours ever since you have been in business, and he has much trouble which is perhaps too true, it unaccountable why you should go so vindictively persecute him. If he violated the revenue laws, which I do not believe, the penalty is severe enough without public ridicule, and if our son, made insane by liquor, found elsewhere than in our home, has committed a crime for which he is a fugitive and a wanderer from home, our suffering on his account is certainly great enough without being taunted with it in so public a manner.*
>
> *I do not believe there is a word of truth in these statements, for if they were true, the temperance people would have little trouble in getting evidence,*

and the officers found plenty of evidence without making a complaint, that they furnish you with the fact simply for the sake of ridicule is sufficient for me to infer that it is all imaginary.

If you have been imposed upon I trust you will enquire into the matter and make such corrections as are just and proper.

In the future you may treat us at least fairly, and if instead of taking-rumor for facts, you will take the pains to get the positive facts before parading us before the public, you will oblige.

April 10, 1881, Maria Arnold.

The underlying tension in Maria's letter was the temperance cause. Temperance got its start in 1804, when Benjamin Rush published his paper in Philadelphia, "An Inquiry into the Effects or Ardent Spirits on the Mind and Body." This spawned the Washingtonianism movement, a national effort to end the sale and consumption of alcohol. By 1841–42, the movement had reached Calhoun County. Raids were held against saloons by temperance people, predominantly women, as early as 1859 in Battle Creek.

Those who took the pledge against drinking were given red ribbons to wear in public, starting in 1876. According to newspaper accounts, usually the ribbon was spotted on "reformed drunkards" in the city. Despite the public popularity of the movement, there were seven operating saloons in the Battle Creek city limits, not to mention a number of shady druggists and unlicensed establishments. The temperance movement played well in the newspapers and soothed local religious leaders, but its effectiveness was minimal if present at all.

The leading organization of the temperance movement in Battle Creek was the Woman's Christian Temperance Union (WCTU). The movement was started in Ohio in 1874, and that same year, it first appeared in Battle Creek. While Michigan flirted with prohibition in 1853–75, it was a law that was impossible to maintain. It was deeply tied to religion, adding to the pressures.

While there is no record noting if Maria's attempt to sway public opinion worked, one thing was clear: Pump was compelled to take action himself, perhaps at the prodding of his wife. Maria was known to be a supporter of the early temperance movement and a celebrated member of the WCTU. One week later, Pump made the papers himself, taking the pledge against the sins of alcohol. As reported in the *Battle Creek Nightly Moon*, "Reformed. A.C. Arnold signed the pledge at the temperance meeting last night and put

Not another drop in Battle Creek, Mich.

Temperance postcard from 1909. Maria Arnold was a leader in the temperance movement, despite having a son as the town drunk and a husband who supplied the men of the city with alcohol. *Author's private collection.*

on the red ribbon, and will hereafter so be known as a prohibition reform man. He told a Moon man this morning that he should never sell another drop of liquor or cider, and was going to sell his hard cider for vinegar. Hope he will stick to it."

If Arnold had any intention of abandoning the main source of his income, he showed no indication of it. The Arnold House still maintained a working saloon on the first floor that was still operating the day after he took the pledge. Clearly his pledge to the temperance movement was little more than an attempt to take some of the public pressure off of him and Maria. The raid that cost him seventy-two gallons of illegally doctored liquor also cost him a day in court with Justice Briggs and a fine of $100 plus court costs.

Justice A.H. Briggs was not spared the covert wrath of Arnold. One morning shortly after his verdict, he awoke to find all of the trees in front of his house girdled, an act he attributed to a vengeful Pump, although no charges were ever leveled.

George eventually made his way back to Battle Creek, but there is no record of Angus McDonald pressing charges against him for the knife attack.

THE BATTLE WITH MAYOR GAGE

Then, on a Saturday night, a tattered tramp entered Pump's (so nicknamed for his earlier activity with the wooden pump business) saloon near the Grand Trunk tracks. Had there been a "skid row" the newcomer certainly, from his appearance, would have resided there. He wore a tattered frock coat, a battered plug hat, his face and hands were grimy, and grimy toes poked from his worn shows. It was at an hour when all saloons were supposed to be closed. But the tramp entered Pump's saloon through an open rear door and ordered a drink. Pump poured and—as the story goes—the mayor whipped off his hat, identified himself and told Pump he was under arrest.
—City Editor's Notebook, Enquirer and News, *October 1, 1963*

Pump Arnold's dealings were constantly the subject of public scrutiny thanks to the local newspapers. On August 27, 1881, an unidentified woman working at the Arnold House (renamed the Exchange House or Exchange Hotel) tried to kill herself. She was identified as a woman of ill-repute, indicating a prostitute, but the publication of the story in the *Michigan Tribune* only seemed to validate what most people thought about the goings-on at the hotel.

For five months, an almost unprecedented period of time, Arnold stayed out of the newspapers for doing anything other than conducting business. In July 1882, that period of quiet for the Arnold's abruptly ended. Pump was arrested for assault and battery with a local citizen, W.J. Robinson. According to the complaint, Arnold hit Robinson on the head with a keg of beer. Arnold fought

The William C. Gage family. Gage did what no one else had tried, going to toe-to-toe with Pump Arnold. *Author's private collection.*

the case but lost. Robinson was awarded $31.16, which included the cost of the beer keg, which was shattered during the attack.

Little did Pump realize that his most public confrontation with the law, before the death of his son, George, was looming. In Battle Creek, it was against the law to sell liquor on a Sunday or after 9:00 p.m. any night of the week. The intent of the law was simple: try to keep drunken activities limited to the early evening hours. Nothing prevented those who wanted booze to purchase a bottle or two before that hour, but saloon owners were expected to lock their tills at 9:00 p.m. It was a law that almost all of them ignored.

Pump's opposition came in an unlikely form: the rather mild-mannered new mayor of Battle Creek, William Claggett Gage. Gage was born on January 10, 1842, and came to Battle Creek in 1867 from Manchester, New Hampshire. Shortly after they settled in the community, the Gages converted to the Seventh-Day Adventist Church. William took a job at the Adventist publishing operation, the *Review and Herald*. After several years of working, he developed health issues that compelled him to move back to New Hampshire for recuperation.

Gage returned in 1878 and took a job as a manager at a print shop. He also became an ordained minister in the Seventh-Day Adventist Church. He also became involved with the Progressive Party, a somewhat right-wing party heavily supported by the church. In 1882, William Gage was elected mayor, "despite the fact that he is not a strong public orator." Gage ran on a platform

of addressing some of Battle Creek's growing problems, one of which was the illegal sale and distribution of alcohol. Arnold had a reputation for vengeance, one that was well earned. Rumors of his burning of George Rogers's home were well known in the city, as was the acid attack on Sam Wardell. Most city police officers didn't seek out confrontation with Pump.

Conflict with Pump Arnold and Gage was inevitable. The stage was set on the balmy, sticky, summer evening of Sunday, August 10, 1882, shortly after 9:30 p.m. A shabbily dressed hobo came to Arnold's bar, let in by one of his employees, seeking to purchase a bottle of whiskey. Pump obliged, not knowing that the seemingly innocent tramp was actually the mayor of Battle Creek in a full disguise of glasses, fake whiskers and a tattered old suitcoat and pants.

Arnold was promptly arrested and let out on bail. Rather than wait for his time in court, Arnold and his cronies opted to attempt to smear Mayor Gage's reputation. Falsified stories of the illegal sale were circulated via the grapevine of the city. It was one thing to be arrested by the police, but being charged by the mayor was on a whole new scale. Pump engaged the services of B.H. Bartow of Portland, Michigan, and O.W. Power of Kalamazoo as his defense counsel.

The trial arrived on September 4, 1882, to a packed courtroom in the county seat in Marshall, Michigan. Mayor Gage was first to take the stand for Prosecutor Wadleigh's case. Gage carefully laid out the entire affair—how he and Chas. C. Lewis went to the Arnold House wearing fake whiskers, glasses and a tattered suit. He went in at 9:30 p.m. and found Mr. Laurie working there. Gage asked for bottle of whiskey and was led by Laurie through a back door in the saloon, where he was introduced to Pump. Arnold sold him a half-pint bottle of spirits for twenty-five cents. The mayor then said that Arnold followed him onto the main street (Jefferson) and asked him to return the whiskey, as he was suspicious that Gage (still in disguise) would squeal on him and cause him trouble. Gage refused and proceeded to the Grand Trunk station.

The prosecution unleashed a surprise witness, of sorts, in the form of John Matheson, a U.S. detective of the Chicago Detective Association, who had been employed by the Battle Creek police. Between August 4 and 17, the detective had stayed at the Exchange House and alleged that he purchased a bottle of whiskey from Arnold personally every night after 9:00 p.m., including Sundays. Combined with the testimony of Mr. Lewis, the prosecution rested, relying heavily on the reputation of the minister/mayor.

Arnold's defense team called Pump himself to the stand in what proved to be a fatal but necessary error. Pump contended that he locked his saloon

973 Marshall, Michigan. Court House.

The Calhoun County, Michigan courthouse, where the Arnolds spent much of their time and where Pump faced charges by Mayor Gage. *Author's private collection.*

until 10:00 p.m. every night. Under oath, he admitted that he had been convicted of selling liquor after hours on prior occasions and conspiracy to fraud in the Snediker case.

Arnold launched an attack of his own, swearing that Detective Matheson was drunk the entire time he was at the Exchange Hotel and thus was unreliable as a witness against him. Under cross-examination by Wadleigh, Pump admitted that despite the fact that the man was intoxicated, he had sold liquor to the man, someone he had characterized as "habitually drunk." This in itself was another violation of Michigan law at the time. Thus Pump had admitted to yet another charge of violating the liquor laws above those he had been charged with in his warrant. In Arnold's accounts, he contradicted himself several times, and Wadleigh smelled blood and kept pressing him under cross-examination, flustering Arnold several times.

Not helping the defense was when Mr. Laurie was called to testify, and his testimony varied from Arnold's, doing much to protect himself and toss Pump to the whims of justice. Several Arnold cronies were called to testify as well. Samuel Wise backed Laurie's version of events over Pump's, which didn't help matters. Mr. Oxtoby, a Grand Trunk employee who lived at the Arnold House, claimed that he saw Gage but never saw the sale of liquor. Oxtoby testified that he spoke with Arnold and told him about the suspected

The old Battle Creek City Hall, Mayor Gage's offices. *Courtesy of Heritage Battle Creek.*

disguise so that Pump would not be snared in the mayor's trap. Unfortunately for the defense team, Oxtoby claimed that Detective Matheson was never drunk at the hotel, contradicting Arnold.

The jury went out at 9:00 p.m. and came back in only a few minutes with a guilty verdict. Pump Arnold was sentenced to twenty days in the county jail and a fine of $50.00 and court costs, making it $68.43 in all—or, in default of payment, ninety days in jail.

After the trial, Mayor Gage attempted to repair his reputation at the expense of Pump's slander campaign. In a three-page letter to the *Citizen* on September 9, 1882, the mayor detailed and justified his actions: "On assuming the duties of the office of mayor, I issued a circular to the liquor dealers, notifying them that the laws regulating their traffic would be enforced so far as they lay in my power to do so. For a few weeks there appeared to be a compliance with the law, but my attention was citied to numerous cases of supposed violation, and it soon became evident that the saloonists were evading the law, and shamelessly disregarding its restrictions. The moral evidence of this was plentiful, but the legal evidence was almost impossible to secure."

Gage further detailed his own role:

> *In securing evidence against Arnold, I simply concealed my identity. The stories about shamming sickness or pain are the tissue of fabrication, and were thus shown to be by the conflicting testimony of Arnold's own witnesses, one of whom heard me say that I wanted whisky to bathe my side, another phthisic, another for spasms. Surely, if anyone made such a claim for pity as all that, he would at once have been denounced as an imposter. The plan facts are these: I went to the place at an hour when he is usually engaged in putting up bottles for night trade, and found him in the very act. I asked for a small bottle of whisky, quieting his suspicions by telling him I was going off on a train that night, which was literally true. He sold the whisky (and himself) for twenty-five cents.*

The public struggled with the temperance movement and the mayor's zeal to enforce the law. In the *Citizen* newspaper on September 30, 1882, Arnold made a public threat regarding the clamping down on the saloons:

> *A.C. Arnold said today: "If these temperance people know what they are about they will stop prosecuting me for selling liquor after hours." Why? remarked a bystander. "Because if they go on these prosecutions the first*

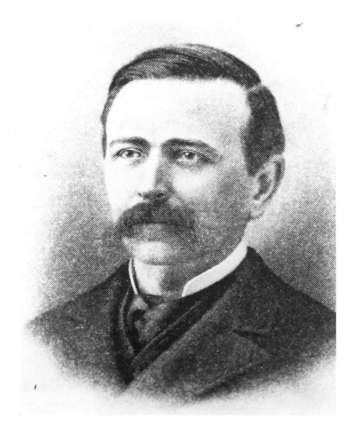

The Honorable Mayor William Gage later in his life, after his tangle with Pump over selling alcohol illegally. *Courtesy of Heritage Battle Creek.*

thing they know I'll sell every dollar of property I've got and leave this town." We submit that Arnold's position is unanswerable. This city can't afford to lose him. He is too valuable an acquisition. Therefore in the name of a public liable thus to suffer an irreparable loss we kneel before Mayor Gage and prayfully ask His Honor to "let up." The City could not survive Arnold's removal to another clime. We hope Mr. Arnold will reconsider his rash determination to leave for _____ where would we be without him.

Clearly, some in Battle Creek felt that it was better to keep Arnold around, warts and all.

If Mayor Gate felt that Pump's arrest was going to deter him, or that he was leaving, he was sadly mistaken. On March 2, 1883, Pump was in front of the judge in Marshall for keeping his saloon open beyond legal

working hours. One month later, Pump was arrested for selling liquor to a minor. Olie Eskridge, a sixteen-year-old, along with several companions were caught on a drunken "toot." According to Olie's father, all of the boys were quite sick the next day—no doubt the result of their first binge. Mr. Eskridge swore out a complaint against Pump, who would, a week later, pay a $50.00 fine and $8.50 for court costs. Pump commented to the newspapers that he considered the fine "the price of doing business in the city."

In the summer of 1883, Pump and his son, George, went on a trip to the national park in Montana and Wyoming. The Arnolds set out with a local resident, a Professor McDonald. What we do know of the trip is that while Pump returned, George did not, remaining in the small town of Livingston. George stayed there more than a year, with Pump telling people that he was at school there, although Livingston did not boast a college. In fact, the town had only been formed three years earlier and was little more than an isolated late-western community. George's time in Montana remained a mystery, but he eventually returned to his hometown.

There were still rumbles of prostitution from the Arnold House/Exchange Hotel. Hattie Wood was arrested for plying her trade in 1884. By early 1885, Pump was once more arrested for selling liquor on a Sunday. This was beginning to be a pattern with Arnold. He was fined twenty-five dollars and noted on the check that it was "for city donation."

The year 1885 marked a significant change for Pump Arnold. Having operated the Arnold House for years, he recognized the limitations of his location. While it was poised across from the Grand Trunk Depot, the Michigan Central Depot at the other end of the city was not covered. Pump also understood that if he was going to capitalize on the sins of Battle Creek, he would need a special building designed just for that. His decision was to create the perfect facility for his criminal activities—be it liquor distribution, prostitution or even gambling.

In 1885, Pump consolidated his landholdings along West Canal Street. The long-empty Arnold Piano works and adjoining properties were purchased. Poised along Sands McCamly's canal, his vision was to have a structure that would be situated near the Michigan Central Depot but be on a larger scale than the older Arnold House. There were several structures near his holdings that he purchased. Most of these had white clapboard houses with green shutters. The Sanderson Building, one of those he purchased and destroyed, was one of the earliest structures in the city, having been built in 1842. Once he had the property secured for what amounted to a partial city block, he commenced with the demolition work.

The Arnold Block as it appeared in about 1920. *Courtesy of Willard Library, Battle Creek.*

Pump arranged for a liquor license for his new establishment, getting Frank Rathbun and George to co-sign for it, claiming that it was a "drug store." Pump then went on a trip to Chicago, where he purchased a new bar for his new building. It seemed an odd choice, given George's inability to hold his alcohol. Pump often bragged that he was building his new establishment for George. Providing an alcoholic with a bar seemed to be a disaster in the making.

There was an air of deviousness in the creation of the new bar in the building of the Arnold Block. The *Battle Creek Moon* noted many years later:

The Arnold block is a four story brick structure with a blue-stone front. The basement is a regular vault, as dark as pitch and twice as dreadful. It begins under the sidewalk where there is a place built expressly to receive stolen chickens. Their puny cackles cannot reach the outside world and no one, not even the police, would think of searching there. The remainder of the cellar is divided into compartments where the light of day never reaches, and one is filled with casks of whiskey from 16 to 18 years old. The others are stored with old stoves, furniture and a thousand peculiar articles, and it is said some of the stoves were put in red hot.

The first floor was originally intended for a saloon and restaurant, but is now unoccupied. The second floor is reached by a narrow stairway, and contains what the old man calls his office. This office is filled with trinkets, watches, jewelry, musical instruments, and, in fact, almost everything under the sun, and is supposed to be the place where George was killed. Dickens' old curiosity shop would not be in it with this collection and when the third floor is reached there is no possible comparison. The remainder of the second floor is divided into sleeping rooms and store rooms, the former being occupied by some shady people.

The third floor is stocked with second-hand goods and there is everything from an organ and a piano to a monkey wrench. A respectable Battle Creek man would imagine he was taking his life in his hands if he ventured into the place.

The organ was part of Pump's ingenious marketing for the Arnold Block. Most saloons at the time had pianos, as was the case in his other hotel on Jefferson. The organ in the Arnold Block was huge, with big brass pipes that ran through the flooring to the story above. It was a wind-up model, and when fired up, it bellowed louder than any piano ever could. Like a mythical siren's song, it could be heard as far away as the train station, seducing anyone

in the area to be drawn into Pump's den of iniquity. The massive organ was designed to pull in patrons from throughout the city to his establishment.

At the time, it was said that the first floor was occupied by the saloon that George ran. The second floor of the building was a billiards hall. The third floor was a gambling casino, Battle Creek's first. The fourth floor was compartmentalized into a hotel-like structure, allegedly used for prostitutes. At four stories tall, it was said to be the tallest building erected in town at the time—making it easier for new arrivals at the train station to spot. It was Pump's crowning triumph for illegal activities.

Another description of the Arnold Block was printed years later during Pump's murder trial:

> The Arnold block was constructed under the old man's personal supervision, and he says the walls were built thick so there would be no chance for them to have ears. Unless a great deal of noise is made in one of the front rooms where the windows look out onto the street, it would be impossible to hear a sound. At different places there are "dummies": large enough to hold a man, and the officers say that when they have been looking for stolen goods, and begun on the first floor, the very goods they were searching for were on one of the upper floors but when the top floors were reached the goods had been transferred to the lower floors. In this way the law has been defeated.
>
> It is declared that mysterious boxes are received at the Arnold Block from all points in the United States, and they contain stolen plunder. It is nothing unusual to observe several crafty people around the block, and it has been noticed that lights are moving around all night, and that in the day time not a sound can be heard. There is one room inside of which no one sees except the old man himself, and there is great curiosity to know what it contains.
>
> A Battle Creek man went through the basement of the Arnold hotel once, and he saw sights that nearly turned his hair white. The cellar was divided into compartments and the doors were of solid iron. Each was locked and yielded only to some mystic touch that the old man had with him. In one of the rooms there was a gold-melting crucible, and suspicious articles and objects abounded.

On December 6, 1886, the Arnold Block opened for business. More than 1,500 men showed up for the opening of the saloon, spilling out onto West Canal Street. Out in front of the new business was Arnold's long-plotted revenge on Mayor Gage: a one-ton statue of a hobo/tramp placed directly in front of the Arnold Block. According to Pump, when he had been in

Chicago purchasing his bar, he had hired a sculptor to create the stone visage of the mayor who had entrapped him. In various accounts, Pump indicated that he had spent somewhere between $500 and $5,000 on the "likeness," which looked nothing at all like William Gage. Few thought that Arnold would spend that kind of money for such a witty revenge. The 1896 *Battle Creek Daily Journal* recounted, "One more story, not so well known, is that Arnold did not order the statue made but, having discovered it at a

A contemporary photo of Pump Arnold's statue of Mayor Gage, now in Manistique, Michigan. *Courtesy of Heritage Battle Creek.*

monument works, bought it because it so well depicted the characteristics of a tramp with his careless stance and tattered clothes." The unveiling of the statue to the crowd was crowned when Pump called out, "There, fellows, stands our mayor!" The mass of patrons erupted in cheers.

It is most likely that the statue was simply purchased as a surplus item from some monument company that Pump had stumbled on or traded in some sort of backroom deal. While Pump often claimed that it was made in Chicago, in reality the statue was manufactured in San Francisco. While it had no bearing in reality, patrons reveled at the vengeance that Pump had attempted. Gage, on the other hand, was not amused. In the following months, he sued Arnold for libel when a label was affixed to the statue that read, "Mayor Gage." Arnold took off the offending label.

The statue became something of a minor landmark in the city. For Arnold's drinking patrons, it was a mark of ridicule and defiance against the law. For holidays, the statue was dressed up. For Halloween, Pump had a coffin built around it. At Christmastime, a scarf and wreath appeared around the hobo's neck. While intended as a prank, there's no way that Mayor Gage would have taken it as anything but a mocking threat.

The statue was taken down for two months in 1893 so that Pump could take it to the Chicago World's Fair, where he claimed that it was put on exhibit, although no record of a tramp/hobo statue being shown has surfaced with contemporary research. It is more probable that the statue was taken to a bar in Chicago of one of Arnold's dark circle of friends rather than the World's Fair. On more than one occasion, the heavy statue disappeared altogether—both times it was found in the bottom of the millrace in front of Arnold's business and recovered. Pump claimed during one of its disappearances that he had sent it to Mardi Gras in New Orleans, when in reality it had been abducted by a number of prankster locals. Regardless of his past reputation, Pump's tribute to George and to criminal debauchery in the creation of the Arnold Block was a stunning success.

The Arnold Block became a center of criminal activity in the city almost overnight. Drunken fights were commonplace. A typical evening was detailed in the *Battle Creek Daily Journal* of October 30, 1889:

> *A row in the saloon in the new Arnold Block about 5 o'clock yesterday afternoon between Smith Bramble and Edward Merritt resulted in Bramble being so serious injured there is fair reason to believe that death may follow. As near as can be learned the quarrel started over a game of poker; Bramble is larger than Merritt, but was so much under the influence of liquor that*

The alleged likeness of Mayor Gage, now in Manistique. *Courtesy of Heritage Battle Creek.*

he could not handle himself, and Merritt's only injuries seem to be his right hand, which was bruised undoubtedly in dealing blows on Bramble's head. During the progress of the row, Bramble was knocked through a light of glass, and his face and head were fearfully cut.

Such instances were the norm rather than the exception, to the point that the police often posted themselves along Canal Street, since they were destined to be called there anyway.

One week later, Pump once more found himself in court. One of his women, May Rumsey, living at the Exchange Hotel and working for Arnold,

was assaulted by D.E. Ryan. The attack had taken place on November 29, but she took two weeks to file charges. Ryan, in striking back at Pump, filed charges with Justice Flint that Arnold was illegally selling alcohol on the premises. Pump personally paid for her legal fees, hinting that she was most likely a prostitute in his employ at the Exchange. In reality, this was likely a case of a trick who roughed up his prostitute, with her pimp taking care of the legal fees. With two illicit saloons operating in the town, Pump was destined to face more legal issues.

If anyone thought that George's drinking days were behind him, that illusion was shattered on July 20, 1887. George was arrested at the Exchange Hotel by Constable Van Horn at the request of his mother, Maria. George had been drinking and had gotten into a fight with his father in the dining room. George got the drop on Pump and pummeled him so badly that the next day his father appeared to have the mumps from the swelling of his injuries. The fight got so out of control that his mother had contacted the police, who placed George in custody for being disorderly. He was scheduled to appear before Justice Flint the following morning once he sobered up, but his mother dropped the charges and paid the court fees "on his promise to do better." It was clear that the old animosity between father and son still was firmly in place.

The struggle between the two men erupted again on August 8 of the same year. Pump and George got into "one of their periodical fights" at the saloon in the Arnold Block. George was arrested by Marshal Hill for starting the brawl and hauled off to jail. Once more, his mother raced to his support. Maria pleaded with the marshal that George should be released, and he did so with the promise that he pay the ten-dollar fine and costs, which he did the next day.

By October 1887, George and Pump had managed to channel their combative energies against a common foe. As reported in the *Battle Creek Daily Moon* on October 15:

> *Last evening Dick Doland went to the Exchange Hotel with a friend to procure lodgings for the night as he says, when he was set upon by the proprietor and his son and driven from the place with a cheese knife. It appears Doland had excited the enmity of the house by making some complaints of their irregularities in managing their liquor traffic. His presumption in asking for lodging under the circumstances was too much for Mr. Arnold and son George, who chased him from the premises. Doland claimed to be in fear of his life and applied to the police for protection and*

they corked him up in the jug, for a night's lodging as a guest of the city. Doland's hand was badly cut which he claims was done by the knife, and threatens to make complaint against the amiable landlord and son. Dick was allowed to depart from the lockup at an early hour this morning.

On November 8, George was arrested for being disorderly in front of the Arnold Block and was held overnight to sober up. When his uncle Ira Daggert, whom George had gotten into a fight with years earlier, came into the city in December, George got into yet another fight with him at the Exchange Hotel. According to the *Battle Creek Daily Moon* on December 17, 1887:

George Arnold runs a saloon on Canal Street opposite the post office, his father A.C. Arnold runs the Exchange Hotel on Jefferson Street. On Wednesday evening George was not very busy, so he filled his tank with "bug juice" and went down to help his pa run the hotel. His services were volunteered, and not appreciated. He was requested to mind his own business but neglected to do so, when his uncle, Ira Daggart stepped in and gave him a pair of black eyes that closed up the dispute.

George was held on $25.00 bail for the brawl, but this time his mother did not pay to get him out. The following day, he was taken before the court recorder and pleaded guilty to being drunk and disorderly. The fine came to $12.80. Rather than pay, George swore that he would rather go to jail for the eighty days, even though the incarceration called for was only thirty days. The recorder, possibly sensing that George was still a tad intoxicated, gave him until six o'clock in the evening to make his final decision.

George took his time and returned at 6:00 p.m. As the *Moon* reported the following day:

One of the most obliging prisoners that Calhoun County has known for many a year is George Arnold. George was sentenced on Saturday to pay $12.80 or in default go to jail for thirty days. He assured the officers that they need not trouble themselves about him; that he would report all right at the jail in Marshall, which he did along in the evening. George went to the kitchen door and tried to get in when Mrs. Prentice thought he was [a] tramp and ordered him away from the door. Subsequently he floated around to the front door of the place, where he again rapped, and told the inmates through the key-hole that he had got to get in. He had been

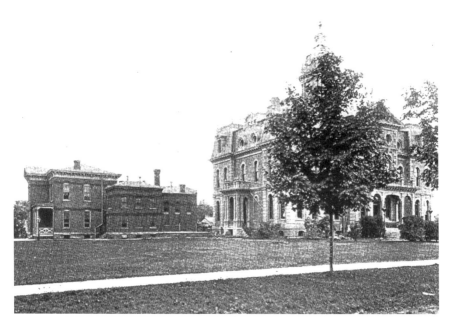

The Calhoun County Jail (to the left of the courthouse), where George spent so much of his time. *Author's private collection.*

sentenced there, and had pledged his word to be on hand. Finally, he plead so that he was heard by Jailor Prentice, [who] took pity on him and let him in and then telephoned here [Battle Creek Police] to see if he was really wanted. George had $14 in his pocket, and his fine was only $12.80, so it is surmised that he felt the need of retreat where he could isolate himself from his companions and habits for a few days. George will probably change his mind as soon as he gets entirely sober, and may be expected home at any time.

Despite having the cash, George stayed in jail, probably in some vain hope of sobering himself out. Any progress he may have made, however, was short-lived.

LIFE IN THE BAD LANDS

George Arnold was arrested to-day at the request of his father, A.C. Arnold, and arraigned before Justice Briggs, upon the charge of being a common drunkard. He pleaded guilty and was sentenced to Marshall jail for 30 days. Mr. Arnold stated that George was a crazy drunk a large share of the time and yesterday dragged his mother who is ill, from her bed and abused her shamefully.
–Battle Creek Daily Journal, *"Courts and Crime," December 12, 1890*

The Arnold Block was not the only drinking establishment in the vicinity. There were four other saloons operating in a six-block area, although the Arnold Block was the only one catering to a wide range of sins—gambling, drinking and prostitution. That portion of the city along the Battle Creek River and canal became known as the "Bad Lands" by the locals. As an editorial in the newspaper decades later recounted, "About it drifted the flotsam and jetsam of life, unkempt, bleary-eyed me with equilibrium unstable and perilous to passersby. It was a neighborhood regarded with fear by the women folk who lived on the South and had to pass that way to get to Main Street."

This was the center of George Arnold's existence, living and working in Battle Creek's Bad Lands. As such, George began 1888 with a stint back in the Calhoun County Jail for drinking. As the *Battle Creek Daily Moon* reported it on January 18, 1888: "George H. Arnold was before the Record this morning for being drunk—George has been absent from the city for the past twenty days, and to celebrate re-entering the social whirl of the city he gave

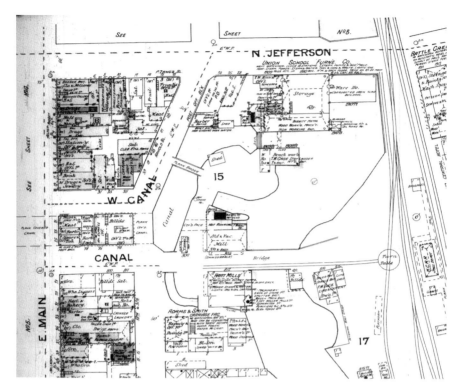

Sanborn Fire Map from 1880, showing the Arnold Block and the "Bad Lands." *Courtesy of Willard Library, Battle Creek.*

the tempting glass a whirl and was whirled into the whirling brain—This morning the Recorder took a whirl at the case and fined George $12.80, or twenty days in the Marshall jail. George will undoubtedly pay." It was reported later in the *Moon* that George showed up at the jail and asked to be admitted: "George is again occupying his old quarters at the county seat."

What seemed to be changing was the public view of the Arnolds. Pump was seen as a vindictive criminal corrupting the entire community, whereas George became the brunt of public abuse as one of the city drunks. A number of men were recorded as constantly being in jail for drunkenness, but none as much as George. Worse yet, the newspapers reveled each time he landed himself behind bars. George's desire to stay in jail at least pointed to an awareness that if left to his own designs, he would get himself into trouble. It was a dose of common sense that didn't stick with him long. By March of the same year, he entered into an arrangement with George and Lee Stoke to purchase a brewery in Logansport, Indiana. For a man with a

drinking problem, the concept of going into the brewing business seemed like a bad plan in the making. Little was reported of what became of the deal, but most likely Lee Stoke rethought the commitment and stability of his partner, as George remained in Battle Creek.

While George struggled with his rampant alcoholism, his father once more was dragged into another prostitution case. On the evening of January 23, 1888, a prostitute named Minerva Whitman was arrested at the Exchange Hotel—allegedly caught in a "very compromising situation," a Victorian-era euphemism for prostitution. Pump assumed the stance that he had no idea what his guests did in their rooms, although this seems entirely implausible. Minerva was charged with being a common prostitute. She was brought before Justice Briggs and tried to plead her case as best she could. As the *Daily Moon* reported it:

> *Minerva was no reminder of the Grecian goddess of war; she was in tears and wrung her hands in the most abject despair, creating quite a scene in the court room. She wanted "to go home" and she would "never do it anymore," and boo, hooed, until an outsider would actually feel sympathy for her. She also said she had the heart disease and was afraid to stay alone, but the justice was inexorable. He sent her where she would have plenty of company, if the quality was not the very best. Minerva has gone to jail, and a well-known character about the back doors of the saloons will be missed for a few days at least.*

Unable to pay the $100 fine, she had no choice but to be sentenced behind bars.

By April, Maria Arnold had begun a multiyear quest to rein in her husband and, later, George. She chose to do this in a very public manner, taking out ads in the newspapers to attempt to curtail some of Pump's less savory activities—namely his loan sharking and bail bonding. Word was that Pump was quickly filling up the space in his new building with collateral that he had taken in and been stuck with over the years. Rather than change her husband's activities, Maria targeted the population of the city, forbidding them from "selling" Pump goods or using him as a bail bondsman. For Maria to make such a public plea was almost unheard of in the period—a sign of the growing tensions in the family.

George was the next Arnold to make the local press. On April 21, 1888, at 9:00 p.m., George became involved with a brawl on South Jefferson Street. According to the account, an employee of the Exchange Hotel, James

Kirkpatrick, had somehow insulted George. The younger Arnold conspired with another employee by the name of Peter Stokes to lure Kirkpatrick out of the hotel on some false pretense and waylay him. Once outside, Kirkpatrick was ambushed by both men and badly injured in the skirmish, his eye cut by the handle of a ladder that Arnold had wielded. What was not mentioned specifically in the coverage of the "street row," but presumed, was the presence of liquor on the part of George.

Both Arnold and Stokes were promptly arrested. Stokes was arraigned before Justice Flint and given bond of $200 to appear at a later date. George Arnold, for the first time in a long time appearing before another justice other than Briggs, got much worse. He pleaded guilty, most likely assuming that he would be given a month or so in jail. Justice Flint was far less forgiving, especially given the revolving door that George had with the county jail. He sentenced George to ninety days in the state house of corrections in Ionia, Michigan.

The sentence shook George. He was given some time to prepare for his trip to Ionia and left the court making "some very empathetic remarks concerning justice and general, and this particular instance of it, especially."

There was a lot of reason for George to be less than enthusiastic about being sent to Ionia. The facility there was new, started in 1883 and finished in 1885. The institution already had a grim reputation. It was named the Michigan Asylum for Insane Criminals. It was not a typical state prison in that regard. The inmates/patients sent there tended to be insane felons, sexual deviants and others. They also were known to take in chronic alcoholics, which is most likely why George had been sent there by Justice Flint. This was a significant step down from the county jail in Marshall for Arnold. He would be housed with violent men, all of whom were labeled as "insane." While it was a reformatory, it was for holding the worst of Michigan's prisoner population.

The *Battle Creek Daily Moon* seemed to relish rubbing salt in an open wound with George's departure to Ionia. On April 21, he arrived at Marshall so that Deputy Sheriff Powell could escort him to Ionia. "George will scarcely feel like celebrating the Fourth of July this year, as 'Liberty's day' will find him as a prisoner."

Being away from town didn't spare George from additional charges. On May 16, 1888, George was brought back to Marshall by Marshal Edward Hill Jr. Before his departure to prison, George had sold two quarts of beer illegally, taking a page from his father's business book. George had claimed to the victim (who was unnamed) that he was a druggist, but the marshal

Minty's, before its eventual collapse years later. This was where George got into a brawl. *Courtesy of Heritage Battle Creek.*

dispelled that lie in court. George was charged with the crime and then once more hauled off back to prison. For a short time, the Arnolds managed to stay out of the courts and out of public attention. Finally, on August 24, 1888, George returned from Ionia in the late summer evening. He had been released early from the reformatory for exemplary behavior.

George managed to stay out of the newspapers for some time, but that quiet spell was shattered in early April 1889. At Minty's cigar and newsroom, he got into a fight with Thomas Dempsey. Minty's was a clapboard structure that was part cigar parlor and part general store, constructed along the millrace not far from the Arnold Block. George and Tom got into a political argument, and George made a derogatory comment about Dempsey's ancestry. Tom answered the comment by punching George in the nose. "George's figurehead is said to be very seriously damaged."

Pump, always looking for ways to draw in potential customers, adopted a strategy of having an attraction outside the Exchange Hotel. Pump somehow got possession of a black bear. The bear was chained to the side of the structure with enough length to reach the sidewalk—just close enough to be a menace to the inquisitive. Postmaster (Colonel) Frank C. Latta went to Washington during the Theodore Roosevelt administration and came home

with a Battle Creek experience told by Secretary of the Treasury Shaw. The *Sunday Record* newspaper printed this secondhand story:

> *Secretary Shaw used to stop at the Battle Creek Sanitarium and on his last visit was accompanied by his little boy. "Pump" Arnold kept a large bear on a chain near the old Arnold House. While waiting for a train and the Grand Trunk depot, Shaw took his son over to see the animal and to feed it popcorn from a paper sack. The boy was very cautious and gave out the corn in small doses until hungry Bruin suddenly made a lunge for him, and in an instant was hugging the boy with all his strength. Finally, however, the bear got the popcorn bag and immediately released the frightened youngster. It was corn the bruin wanted, not boy-meat.*

As much as the bear was dangerous and untrained, it didn't violate any laws, so it was tolerated by the locals, who chalked it up to another one of Arnold's quirks.

Pump's flagrant ignoring of the law landed him in court in late May 1889, once more violating the city's liquor laws. The witness Pump intended to call to defend himself was James Kirkpatrick, the same Kirkpatrick his son, George, had ambushed and badly beaten. Arnold told the court that Kirkpatrick could clear up the entire matter but had disappeared, thus weakening his case.

The reality of the situation was that Kirkpatrick had fled to Toledo for stealing the watch of a B.F. (Frank) Randall. His arrest made getting him in for Pump's defense problematic at best, which Pump declared was denying him the defense that he deserved. As with many things around Pump Arnold, the matter was more complex. It seems that Kirkpatrick, Randall and George Arnold had put together a sideshow attraction: a "living mermaid," allegedly caught by Kirkpatrick in local Goguac Lake. George and the two co-conspirators had taken their mermaid to Kalamazoo, where it was said to be generating a great deal of attention and, presumably, revenue. Oddly enough, the Battle Creek newspapers did not cover the story of a captured living mermaid from the lake that provided the city with its water supply. Apparently, even George realized that the locals would not buy into such a preposterous scheme.

The prosecution contended in Pump's trial that the entire sideshow scheme had been created as a convenient way of getting Pump's witness out of town. None of the less-than-brilliant conspirators had anticipated Kirkpatrick landing himself in a Toledo jail, however. In fact, Randall testified in court

that Pump had offered him $500 to ensure that Kirkpatrick was unable to attend the trial—hence the charge of Kirkpatrick stealing a watch. Pump's attempt to bog down the court resulted in a hefty $100 fine, hardly enough to cover the inconvenience of the marshal in tracking down Kirkpatrick. His payment brought an end to George's career as a sideshow manager.

Maria Arnold once more took to the press to try and fix her problems at home. She took out an advertisement in the newspaper for a month, offering a reward of twenty-five dollars for "the conviction of any person furnishing my son George Arnold with intoxicating liquor." By today's standards, this seems idle folly, but under Michigan law at the time, this was a posted civil reward, which empowered the court to act on the reward. Pump took out a similar advertisement in his own name, offering a twenty-five-dollar reward for the prosecution and conviction of "any party procuring for George Arnold any alcohol or intoxicating beverage from any drug store or saloon." He apparently didn't count his own establishment as a possible source for George's drunken fuel.

The courts wasted no time enforcing his mother's desires. On September 30, 1889, Justice Flint filed charges against Harry Coleman, aka "Slick," for selling alcohol to George Arnold. Slick Coleman was himself "in the soup" when he had been arrested and was put on a $200 bond. It sent a clear message to the community that as far as the courts were concerned, they were fed up with George's drinking. George, too, was arrested and sentenced to thirty days in the county jail. Slick received a thirty-day sentence as well, and upon his release, he agreed to leave Battle Creek, while George remained.

While Maria focused on George's drink, Pump was once more dealing with legal issues. On October 13, George Eskridge and Pump got into a fight on Canal Street a few doors down from the Arnold House. Eskridge got the better of Arnold and threw him down into the recently dug cellar for the McKinstry Block. While Arnold swore out a warrant for his arrest, Eskridge thought flight the better part of valor and fled Battle Creek.

The summer of 1888 was celebratory in Battle Creek. The old Michigan Central train station was closed, replaced several blocks down by a new red brick station. The brick and stone structure was accentuated with Michigan oak in the interior. Topped with an stately clock tower, the opening of the structure signaled change in Battle Creek and was greeted warmly by the citizens. Most cities had only one train station; Battle Creek had two—both bringing thousands of people through the city.

The city was changing dramatically. Dr. John Harvey Kellogg, a devoted Adventist, had transformed the Western Reform Institute into the Battle

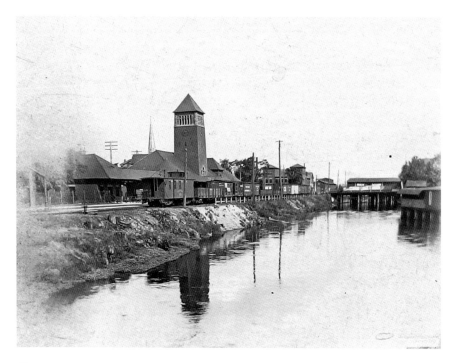

The new Michigan Central Depot, built in 1888 along the Battle Creek River, some two blocks west from the original site. *Courtesy of Heritage Battle Creek.*

Creek Sanitarium. Known as "the San," it was the Betty Ford Clinic of its era. Thousands of people came to Battle Creek for the San's mix of healthy diet and lifestyle based in the Adventist teachings. Celebrities such as Mary Todd Lincoln came to the San for treatment, exercise and diet training. Dr. Kellogg ran one of the largest food research and development laboratories/kitchens in the world. He was constantly exploring alternative ways to prepare grains for consumption by his patrons. Innovations such as granola came from the kitchens and mind of Dr. Kellogg. By the summer of 1888, the biggest employers in the city were the Grand Trunk railroad shops and the Battle Creek Sanitarium. Rumors even abounded that there tunnels running from the new Michigan Central station to the San to allow celebrities to make their way to the health institute while avoiding public scrutiny.

George got out of jail on November 1, 1889, having served his thirty days. In the cool morning hours, he made the eight-mile journey back to Battle Creek, stopping long enough to secure some alcohol to warm his ride. When he got home before noon, his arrival stirred his father's ire. The two men got into a "war of words." The exchange quickly boiled over into a fistfight

between father and son. Pump swore out a charge that George had attacked him first. George was quickly rearrested and taken before Justice Briggs for assault and battery. Bail was set at $109, which George did not have.

Three days later, George's trial came up, and he pleaded guilty to assaulting his father. His fine was $10.46. Justice Briggs forced the younger Arnold to sign a paper noting that "he is not to drink any more liquor, and is to treat his father with becoming respect."

George branched out his criminal enterprise in February 1890, shifting to robbery. George, along with Rance Byington, robbed a Chicago native, H.C. Anson. Their victim had been at the Arnold Block and apparently made the mistake of showing some of the $175 he was carrying. Arnold and Byington took his money and other "valuable papers" after a brief fight that left Anson injured. It can only be assumed that the duo let slip to someone regarding their involvement with the crime. Both were arrested with a $1,000 bond. Pump put up George's bail, but Byington remained behind bars. The pair were pulled three times in front of the judge, but the prosecution was hampered by the fact that once Anson got his papers back, he was understandably reticent to return to Battle Creek for the trial. Charges against the two men were dropped.

In March, while he tried to cope with the robbery charge against himself, George appeared in court, only this time as a complainant. George was attacked while working at the saloon in the Arnold Block by Chas. M. Patterson. While he initially filed the charge for assault and battery, George lowered the charge down to drunk and disorderly conduct, which Patterson paid to the tune of $7.80.

In November 1889, George had signed a paper saying that he would "treat his father with becoming respect." In June 1890, he demonstrated that the paper was worthless. Marshal John Williams was called out for a street brawl out in front of the Arnold Block. Once more George and Pump were going at it, pummeling each other with mad abandon, with George letting fly with the first blow. Both were charged with fighting on a public highway and promptly arrested by the marshal. Pump was released on his own recognizance, while George was required to pay a $100 bail. Both pleaded guilty and paid their fines. One thing was clear: father and son were going to be at each other's throats again—it was only a matter of time.

The election of 1890 was not one that garnered a great deal of Michigan enthusiasm. It was not a year to elect a governor, and there was not a hotly contested representative race. Elections at the turn of the century were reasons for celebration regardless of the liveliness of the political debate.

Bars were often packed, as results were telegraphed in to cheering drunken patrons who cared more about the partying than the political parties. Interest in politics was always high, and the revelries associated with them were a form of entertainment for the male populations.

George Arnold once more was tending bar for the festivities. While he was walking from his room to his father's residence on East Jackson Street, he crossed the bridge spanning the millrace on Jackson Street. While crossing, most likely with a stagger, he was accosted by three men—John Harney Jr., Ed Murphy and Thomas Quinn. George allegedly engaged in conversation with the men and sensed nothing wrong. Without provocation, the men rushed him, hoisting him up and throwing him in the icy waters of the millrace. At that time of the year, the millrace would have been an instantly sobering chill, and since it was a source for channeling sewage out of the city, it would have left George reeking. Caught off guard, George felt that he nearly drowned, and the trio, rather than offering help, seemed to delight in his plight, laughing at him as he struggled to climb out of the frigid race.

George swore out warrants on his attackers, enjoying a rare time being the plaintiff in a legal issue. John Harney gave Constable Cooper and a fellow officer a run as he attempted to flee from arrest. Harney was apprehended after his flight, pleaded guilty to George's charges and received ninety days in the House of Corrections in Detroit, most likely for resisting arrest. Thomas Quinn was given the option of paying twenty-five dollars or spending ninety days in the same institution. Ed Murphy was more cunning than his colleagues. He swore out a warrant against George, claiming that he had started the altercation that had led to his dunking, despite the fact that his comrades had not indicated that George had instigated the attack. The tactic for Murphy worked. The two men agreed to drop the charges against each other, with Murphy walking free.

On December 8, 1890, George turned his drunkenness on a new victim: his mother. His mother had been ill for a few days, and an inebriated George dragged her from the bed and verbally abused her. For Pump, it was too much. He swore out a warrant on his son for being a common drunk.

THE ROAD TO PURGATORY

Guy Crafton, a small boy who lives on River street and sells pop corn, was run over yesterday on Maple street by A.C. Arnold, who was driving at a very rapid rate.
—Battle Creek Daily Moon, *"Moon Beams," July 21, 1891*

The year 1891 continued George Arnold's spiral of drunken lawlessness. He was arrested late in the evening on January 16, creating an intoxicant-fueled disgrace on Main Street. Officer McNanney apprehended the staggering, loud Arnold, and he was hauled to court the next day, to the tune of $7.80. George paid the fine, dodging the ten days in jail.

George was in trouble again in early February. He showed up drunk at the local restaurant of E. Pfander on a frigid snowy February 5. He placed an order and then attempted to steal several luncheon food items while the waiter was distracted with his order. This was not the first time that George had done this, but this time, the waiter caught and confronted him with the theft. George's response was to come out with fists swinging, apparently hindered by his early morning consumption of alcohol. The waiter got the best of him, bloodying his nose and driving George out onto Jefferson Street, leaving a crimson trail in the muddy snow from the day before. The restaurant swore out a warrant for his arrest for being a common drunk. The police had no problem tracking down the younger Arnold, and he was hauled before Justice Briggs once more, badly battered at the hands of the waiter. "George bears the look of having met the enemy and being theirs, judging from his personal

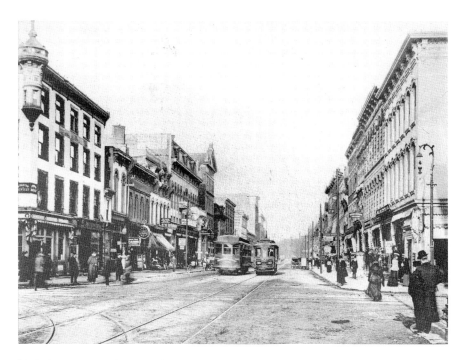

Main Street Battle Creek in the 1890s, roughly at the time of Arnold's trial. *Author's private collection.*

appearance," noted the article in the *Battle Creek Daily Moon*. The bond for the fight and the theft of food was $200.

Things didn't get better for the younger Arnold. George was arrested on February 11 on the roof of the Arnold Block building, where he was putting on something of a late-night show for passersby. At the time of his arrest, George's explanation to the arresting constables for being on the roof was that "I tried to roost so high the chicken thieves couldn't reach me." The judge was not at all amused with his theatrics, leveling a sentence of sixty days in the county jail.

George was later pulled from his cell to appear to his restaurant theft charge. The Calhoun County legal system was beginning to grow weary of George's debauchery. When he finally went to court, Justice Briggs informed George that he would have to pay the fine of $32.52 or he would be sent to the Detroit House of Corrections. The revolving door of the county jail was over in Briggs's mind. The threat seemed to make an impact, if only for a short period. George pleaded guilty and paid his fine, only to return to the county jail.

George was not the only family member with issues with the law. In the early morning hours of Sunday, March 22, 1891, the police were forced

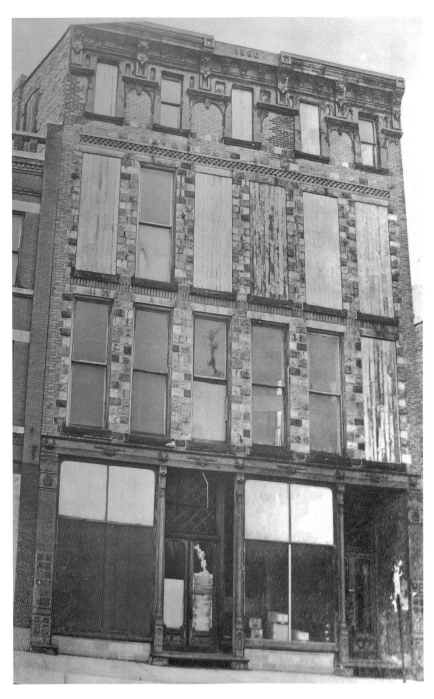

The Arnold Block before its destruction. *Courtesy of Heritage Battle Creek.*

to raid the saloon of the Arnold Block. Not only was the saloon operating after legal hours, but it was also very loud and involved underage women. According to the *Daily Moon*, "Officers McNaney, Shoup, and Finley proceeded to the room, which was on the third story of the block, where they forced the door open and found four young fellows and two girls of very bad character. The girls were dressed in their night wardrobe, and one of them was dancing the 'can can' as the police came upon them. They were taken into custody and lodged in the city jail, where they were guests over Sunday." Katie LaPoint Charlotte and Ida Jarkett of Marshall, both seventeen years old, were charged with disorderly conduct. The young men were hauled into the court as well, one of them being Ben Van Buren, of the prominent community family. All of them pleaded guilty for the boisterous party, paying their fine. As the paper noted at the time, "Something should be done to keep such young girls of questionable character from walking on the streets at night. In some cities the police take such people and lodge them in the jail if they are found on the streets after a certain hour at night." Pump claimed to not be responsible for the actions of his patrons, and since his doors were closed, he had complied with the liquor laws. The officers apparently agreed, sparing him any time in court himself.

By the end of the month, Pump did manage to get himself arrested, this time for vandalism. On March 30, he was arrested by Undersheriff Powell on a warrant filed by Leopold Werstein. Arnold apparently had an issue with money loaned to Werstein and took it out on the window in front of his store's glass showcase. At about 10:00 p.m., Pump allegedly took his diamond ring and cut the glass of the window of the sample case in the full view of witness, scoring it deeply. He was released on a $1,000 bond for the crime. The case of *The People v. Adam C. Arnold* convened in April with three witnesses—Frank Zang, Mr. Foley and William Bryton—who were in the saloon at the time, saw Arnold scoring the glass and chased him away from the front door, around the corner on West Main and then down McCamly Street, where they identified him as he ran under a "bright electrical light that was shining." Their identification of Pump as the culprit was fuzzy at best, given that they had only seen him from behind and, as pointed out in court, the men had been drinking for several hours before their pursuit. The damage to the glass was estimated to be $57.

Arnold's defense team didn't muster much in the way of defense other than to file for several delays. The tactic apparently worked. By September, the jury came back with a dismissal, claiming that there was not enough evidence to convict Arnold. Ironically, at the same time that Pump was

getting his case dropped, George was also in court, once more charged with being "a common drunkard." Pump had to have been present when Justice Briggs reached the end of his patience. He "removed him [George] from the baneful influence of liquor and enticing friends by sending him to the 'Detroit Workhouse' [prison] for three months." George was not given time to say goodbye to family and friends, instead being promptly hauled off to the prison.

In August, Arnold's much-beloved bear attraction disappeared from the hotel on Jefferson Street. Several C> employees saw the bear being led away by a pair of men. The bear had become a much-feared icon of the Exchange Hotel, and Pump was infuriated that his attraction had been stolen. He offered a twenty-dollar reward for the arrest of the thieves. The culprits were never brought to justice, and most of the citizens in the area were happy that the bear would no longer be terrorizing passersby.

More bad news came for Pump in December 1891 when Maria was diagnosed with cancer. Her social absence was noticed, and the newspapers covered the fact that she had cancer. In 1891, such a diagnosis was a death sentence. Maria was the one thing that held her tumultuous husband and son together as a family. She brought respectability to the Arnold name because of her involvement in the community.

Maria's sickness seemed to sober the activities of her husband and son. Both managed to keep out of court and jail for an extended period of time. Pump's only involvement with the law was in May 1892, when a cohort of his, James Dilly, was arrested for "keeping a house of ill fame." The police raid on Dilly's home netted two men and two women who were caught in compromising positions. Pump made Dilly's bond of $300, presuming that his friend would honor his commitment to go to court. Dilly had other ideas and fled Battle Creek, leaving Pump stiffed for the bond.

In early August, Maria Arnold began to take a turn for the worse. On August 4, she was admitted to the Nichols Memorial Home, a local hospital, for what was described as a critical surgical procedure. Any kind of surgery during the Victorian era was fraught with risk, and cancer treatment tended to be a brutal assault on the body. Maria's condition was so bad after surgery that no one was admitted to see her, including family.

For George, the operation was too much for him to bear. In the same newspaper where his mother's condition was detailed, so, too, was his arrest for being drunk in public. He was hauled before the court and given bail of $200. Unable to pay his bail, George remained in jail as his mother crept closer to death.

The Nicols Hospital, where Maria Arnold died. *Author's private collection.*

Four days later, the newspaper reported that Maria was near death. During the night of August 9, 1892, she passed. With her demise, the only force that held her husband and son at bay was gone. Maria fulfilled a role like a control rod in a nuclear reactor, constantly at odds with her husband's dark business dealings and the corruption it brought down on her son. Without Maria, George and Pump were destined to come to blows again; their clash was almost a foregone conclusion.

The outpouring for Maria Arnold was large and mournful. Her obituary spoke volumes of her contribution to the community:

> *The deceased was well known and very esteemed in the community. She was a woman of excellent judgment and good sense and in no way calculated to stimulate anything like malice in the breast of anyone with whom she came in contact. On the contrary she was constituted to win respect and gratitude from all who knew her. She had "malice towards none but charity toward all." She will be especially remembered as the friend of the poor and unfortunate whose interests were very near to her heart, and whose cause she unselfishly espoused.*

Pump told reporters that he planned to erect a granite monument to Maria's memory at a cost of $4,000. He claimed that it would be more

than forty feet tall and would weigh fifty tons. It was all a lie to the reporter, designed more to build up his image as a loving husband rather than actually honor his beloved wife. During his lifetime, no monument was placed on his wife's grave site. Only Pump would have the audacity to use his wife's funeral to his own self-promotion.

The new year began with Pump once more clashing with law enforcement, this time over the world's oldest profession. He was charged on February 24, 1893, for "letting the house to parties with the knowledge that it was being used as a house of prostitution." The property in question was on the corner of Canal and Van Buren Streets and had been rented to Miss Kittie Brown. Pump denied any such knowledge and even went so far as to say that he really didn't know Kittie. Most in the city didn't buy his story, and with good reason. Pump was at the center of a news story three months earlier claiming that a party in Coldwater, Michigan, wanted to purchase his prize horse, "Kittie." While it might be a coincidence that his favorite horse and a local madam working in one of his properties had the same name, most people felt that was far too great of a stretch of the imagination.

The arrest was the result of a brawl between some of Miss Brown's working girls. Miss Ella Bear got drunk and engaged in a fight with Minnie Stevens. Ella was described as "a big working girl," while Minnie was said to be small and frail, "and it is only a few weeks ago that she entered a life of shame." Ella Bear was well known to authorities, having been arrested several times before for plying her trade on the streets of Battle Creek. The fight was entirely one sided. Minnie's arm was badly wrenched, and she was beaten severely by the larger woman. The sheriffs were attracted to the commotion and broke up the brawl, with one of the deputies getting injured by Miss Bear in the process.

Pump found himself pulled in with the women before Justice Henry. Ella Bear, "who is a bear by nature, as well by name," was charged with being a common prostitute and assault and battery, both on the arresting deputy and Miss Stevens. Still with a head of steam, she swore to testify against all other parties involved, including claiming that Pump was indeed aware of the illegal activities of Kittie Brown. Miss Brown was charged with running a house of prostitution and pleaded guilty, opting to pay the $24.00 fine. Stevens was charged with being a common prostitute and paid her $5.20 fine, having also pleaded guilty. Arnold protested his innocence but was hard-pressed to convince Justice Henry that he knew nothing about what Kittie and her girls were doing. It took the better part of two months for Pump to get the initial charge thrown out of court, as "nolle prosed, as the

ordinance was not strong enough to convict." He was immediately rearrested under a new charge of letting a house for immoral purposes. Minnie Stevens testified against him, fully implicating him as profiting from Kittie Brown's operation. Pump's lawyers dragged it out for five months before he finally acquiesced, changed his plea to guilty and paid the $100 fine.

Pump's loaning business drew legal attention later in the month of February. William Harrison worked at Benjamin Van Praagh's cigar store and broke in, stealing a quantity of cigars. He sold the cigars to Pump, and when the police began their search, they were discovered at the Arnold Block. Harrison had skipped the city with the money Pump had given him for the stogies, and Arnold found his smokeable collateral in the possession of the rightful owner. Harrison was captured in Bay City, Michigan, and Pump found himself in court for the cigar case and the prostitution case on the same day with the same justice. Quite literally, he was spending more time in court during the day than minding his businesses.

George had been relatively quiet and out of the public eye since his mother's demise, mostly because he had been in jail. In April 1893, George became injured by a bad fall. He had gotten himself locked out of a room at the Arnold Block that he needed to get into. Rather than seek out a key from his father, George went out through the window and tried to climb around along the window cap to access the room from the outside. Opening the hallway window and stepping out, George lost his footing and fell two stories. Rumors abounded that George had been intoxicated during the entire debacle, which seemed entirely plausible, but Pump argued in the newspapers that alcohol had not played any role in the accident. The injuries he sustained were fairly severe; it was two full weeks before newspapers reported that George was finally able to sit up in bed. One month later, he was finally able to stand and get out his room, if only for short periods of time.

By July, George had recovered enough for travel. He went to the Chicago World's Fair for several days. The attraction that caught his eyes was the Old Kentucky Distillery, which was no surprise to the citizens of Battle Creek. George was said to tell people the intricacies of how the distillery worked with vigor and excitement in his voice.

The trip to Chicago seems to have triggered George's indulgence in distilled spirits. By September, his father had taken out a full month of advertisements in the *Battle Creek Daily Moon*, offering a twenty-five-dollar reward for the conviction of any party purchasing or procuring George liquor from any drugstore or saloon. It was the same tactic that Maria had undertaken with little to no success. While he was not in trouble with the law,

it is clear that George had taken to the bottle again. This was reaffirmed on October 18, 1893, when George got into a drunken brawl with a local man, George Fonda. While Arnold was only charged and fined for assault and battery, it was clear that he was once more falling into his old patterns. His father paid his $5.70 fee to get George out of jail.

A few days later, Pump's father-in-law, Henry Dygert, passed away. For the first time since his departure under the charge of arson, Pump returned to Oneida, New York, since he was named as legates in his estate. Henry left money for both Pump and George. The senior Arnold held on to his son's portion of the inheritance. This could have been an act of greed or simply to prevent George from losing the money while drinking.

By the end of 1893, Pump was once more in court, this time having filed a warrant against Charles Sutliff. Pump alleged that the younger man had stolen a bicycle from Arnold. Sutliff countered with his own suit, claiming that he had tried to obtain a loan on a bike wheel from Pump to the tune of four dollars—signing what he thought was a receipt. Arnold had given him a receipt for five dollars, which Sutliff had unknowingly signed. Pump had attached the wheel to a bike and claimed "absolute ownership of the machine," and when Sutliff came back to reclaim his wheel, he was told that it was now twenty-five dollars for the wheel and the rest of the bike. Charles Sutliff was unwilling to be swindled by Arnold and allegedly stole the entire bicycle. The two men settled out of court, with Sutliff getting his wheel back.

With the start of 1894, a change came over Pump Arnold. On January 19, an article ran in the *Battle Creek Daily Moon* that caught the attention of both the public and undoubtedly law enforcement:

> *Strange things are happening now days. For a week past rumors have come to the ear of the Moon reporters that A.C. Arnold was about to sell all of his property and give the proceeds to the missionary cause. We gave not attention to the rumors until Mr. Arnold brought in an advertisement yesterday for insertion in the Moon, offering for sale his brick block on West Canal Street, his hotel The Watkins House, eleven houses in the city, six vacant lots, and one farm; in fact, all of his earthly possessions. The advertisement says that he desires to retire from business cares. The Moon reporter called upon Mr. Arnold and found him lacking in his usual jocose manner but he appeared quite sad and meditative. When asked about the circulated reports concerning him and the reason for the sale of all his property, he would make no reply. The unexpected always happens. If Arnold really does experience a change of heart and joins the church we*

shall be willing to believe our Adventist friends are right, and that the world is coming to an end.

It seemed that Pump indeed might have been getting ready to change to a retirement lifestyle, much to the relief of the Battle Creek citizenry.

Both Pump and George remained out of the public limelight throughout most of 1894, with a few minor exceptions. The Battle Creek City Council was considering paving the downtown streets. This was part of a larger effort to lay sewage pipes in the city, the first true centralized sewer in Battle Creek. There were two proposals on board: one was for concrete paving, and the other was to use red bricks, as had been done in Grand Rapids. Pump was strongly against the use of bricks and went so far as to offer to pay for the concrete paving in front of the Arnold Block to avoid having bricks used. Despite his protests (or perhaps because of them), the city opted to move forward using brick.

Autumn brought about a first for Battle Creek: the visit of Barnum & Bailey Circus. While other circuses had been to the city before, this was the first time the city had entertained the world-class show of Barnum & Bailey's productions. At the same time, in August, Martin Arnold returned to the city as well. Martin had been Pump's partner in their wooden pump business more than twenty years earlier. Martin had not been to the city in more than two decades.

Pump's coat was stolen in October 1894 when he left it hanging on a peg in his office in the Arnold Block. According to Pump, the coat was expensive, and it had a diamond pin in the lapel that was worth more than $500. The old man offered a stingy reward of $25 for recovery of the stone and $25 for the evidence necessary to convict the thief. Not surprisingly, no one came forward to turn over the $500 gem for a paltry $50 total reward.

On December 18, 1894, Pump contacted the newspapers with what seemed to be a minor news story: George had disappeared, and his father wanted to post a reward for any information as to his whereabouts.

GEORGE ARNOLD GOES MISSING

Some people are of the opinion that persons with a speculative turn have secreted George in the city and are holding him with the expectation that his father will offer a good reward.
–Battle Creek Daily Moon, *"Still Missing," December 21, 1894*

The first inkling that the citizens of Battle Creek had that George Arnold might be dead came from his father, Pump. The senior Arnold reached out to the *Battle Creek Moon* and reported that George had gone missing on Sunday, December 16, but Pump did not reach out the newspaper until the eighteenth, two days after he had allegedly disappeared.

In the account Pump told the press, George had been sick on Sunday and had spent most of this day in his father's office in the Arnold Block, resting on the couch there. Pump had prodded him to go home, to 100 West Jackson Street, and rest there, but George had insisted on staying with his father. By Pump's account, George had been acting strange all day, "delirious from his fever." At 7:00 p.m., he was taken home and went to his bedroom on the ground floor.

The next morning, Fred McDonald, Pump's aide de camp and semi-adopted son, alleged that he had awoken and noticed that a light was burning in George's room. McDonald went in and found the bedroom empty. The window was open, and footprints from there indicated that George had climbed out, although why he had left through the window remains a mystery. McDonald claimed that he had checked the nearby area and that a young

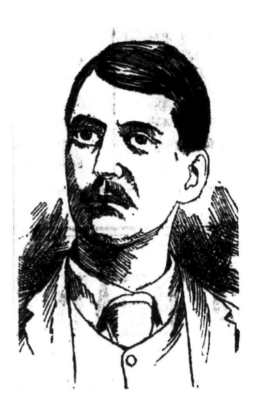

Right: George Arnold, town drunk and murder victim. *From the* Battle Creek Moon, *February 11, 1895.*

Below: Pump's adversaries: the Battle Creek Police Department, 1890s. *Courtesy of Heritage Battle Creek.*

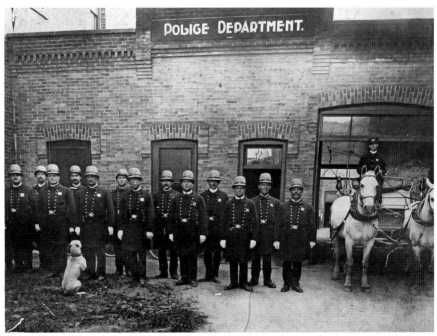

girl in the next house stated that she came home at 9:30 p.m. Sunday night and had seen George standing in the yard. George Arnold had supposedly walked away, up Jackson Street, toward the city. Constable Hamilton of the Battle Creek Police Department telegraphed a description of George to the neighboring towns, requesting that officers look out for him. Pump claimed that George had taken no money with him when he left. The police never searched any of Pump's buildings or even the Arnold Block itself. Pump was taken at his word that George was not on the premises.

The following day, December 19, the police posted an ad searching for information on George's whereabouts. "When last seen he wore a black soft hat, black sack coat, light colored vest, dark pants and colored shirts. He had about ten days' worth of beard on his entire face, dark eyes, dark complexion, about five feet nine inches tall, weight 135 pounds; was poor in flesh owning to recent sickness."

While the police were just stepping up their search for George, Pump was telling the press that he had given up on his son:

> *A.C. Arnold had given up all home of finding his son George alive. Search has been made for him for three days but up to this afternoon there is no clue as to his whereabouts. He believes that George is drowned, and will ask the company to let the water out to-morrow. He has sent postal cards to all neighboring towns giving a description of George. This morning Mr. Arnold expressed himself in the presence of Sheriff David Walkinshaw as believing that George was dead. The sheriff said that he did not believe it and that George would turn up all right. He offered to bet Arnold $10 that George was alive. Arnold took the bet and deposited $10 each in the hands of Deputy Sheriff King.*

Pump organized his own search of the canal and Battle Creek River, although his efforts seemed to be almost counterproductive. Pump insisted that the search for George only be conducted at night, by torchlight. He tried to hire an experienced river man, James T. Buckner, to lead the effort, but he refused because Arnold would only put his own men on the boat to do the searching. Buckner wanted to put his men in his boat to do the work. Pump turned to a loyal local African American hand who lived in one of his houses, John Leek, to conduct the nighttime search. For three nights, the inexperienced Leek worked his way around the waterways, drawing attention from passersby.

To anyone who would have stayed up late to watch, it would have appeared like a scene from a Sherlock Holmes story, with fog hovering over

A 1980s view of the Arnold Block from across the Battle Creek River, with a good view of the canal. *Courtesy of Heritage Battle Creek.*

the icy river and a small boat with a lantern wavering in the shadows, slowly plodding along. If there were any witnesses, the newspapers never found them. To everyone it seemed a bizarre way to conduct a search, if indeed that was what it was.

Pump's bizarre instructions and approach to the search for his son seemed nonproductive. At night, even with lanterns and torches, it was almost impossible to see under the piers and other possible resting places. Still, Arnold insisted that he was leading the efforts to search for his missing son.

On December 21, with a biting winter wind whipping through the streets, the city closed the locks to the millrace and began the tedious process of pumping the water out. The millrace ran right in front of the Arnold Block, and Pump himself felt that George would be found there. Police officer Lunt took control of lowering the head gates at the start of the race, while Chief of Police Elliott and two other officers manned the waste gates. The entire process took long hours, letting gravity slowly pull the water into the Battle Creek River. A crowd of several hundred people lined the millrace—the only entertainment in the city for the day. Officers Buckner and Farrington got a small rowboat into the race and moved under the buildings and bridges

that poked out over the race, looking for any sign of George. In the frigid winds, the citizens all watched, hoping for a glimpse of a dead body, but they were disappointed. After hours of cold, unforgiving work, the race was nearly dry and there was no sign of George's body.

Another potential clue came from the night crossing tender for the Michigan Central Railroad at Jefferson Street. He claimed that on the night that George disappeared, Arnold had come down between 11:00 p.m. and midnight, attempting to get through the gates to go the depot. George had walked down the sidewalk to the station and then had returned and went up Jefferson Street. The gate tender said that he had been acting strange and was evidently not in his right mind.

Jerry Rall, a wagon maker whose business was on West Canal Street in the Gardner building, told officers that he saw George on the Tuesday morning after his disappearance at 8:00 a.m. walking slowly on the walk opposite of his shop, along the side of the street of the old post office. His account was supported by John Leader.

On the day after Christmas 1894, Will Clapp discovered the body of a man floating in the Kalamazoo River near Edmond's planing mill. The body had become lodged on a sandbar near the bridge on West Canal Street. The presumption was that it was George Arnold. Will went to the city to get police officers, who joined him, pondering if it was a body or merely a bundle of clothes and wondering how they would get it recovered if it was a body. Eugene Munger settled the matter, braving the ice-cold waters and wading out to where the body lay. Fireman Charley Ireland brought a pike pole and assisted Munger in getting the body ashore.

It was the mortal remains of Isaac "Ike" Harrison, a local man. Harrison was well known in the city. A former slave, his parents had moved to Mexico with their master, and he had migrated across the border after the war and settled in Battle Creek. Harrison worked as a teamster in the city, working for years for Mason & Rathbun, local lumber dealers. Ike did odd jobs as well, oftentimes hired by Pump Arnold to haul whatever cargo he needed transported.

While he was arrested several times for being a drunkard, his reputation was nothing compared to the bar that George Arnold set. On two previous occasions, he had been fished out of the canal and the river, nearly drowning after stumbling in after a bender. It appeared that the third time was not the charm for him. Drinking wasn't the only thing for which Harrison was known. In May 1881, he had shot and badly injured Emma Hill, "a woman of low repute." She had refused to press charges, and at the time of his initial arrest, Ike was said to be extremely intoxicated.

If that wasn't enough, Harrison had been married for decades but seemed to have an ongoing relationship with a younger woman, Nellie Jones, who was a servant for R. Kingman. In December 1881, he had broken into the house and locked himself in Jones's quarters. When she discovered Harrison there, she contacted the Kingman family. Mr. Kingman got out a ladder and had Nellie climb up to her room. From the window, she could see Ike hiding under her bedclothes. Ike had claimed that he had been "thar" before, but the officers quickly confirmed that Nellie didn't want him there. He was charged with burglary and left to fend for himself with his wife on the matter.

The coroner held an inquest to determine if Harrison's death was anything other than a drunk stumbling into the river and could find no marks or bruises to indicate that Harrison had done anything more than simply drown of his own accord.

The last time Ike had been seen was at 9:00 p.m. Earlier on Christmas Eve, Harrison had withdrawn $45.00 from the Battle Creek Building and Loan Association. He purchased a new suit of clothes and paid off several debts that he had. That night, he had been seen drinking at several establishments in the Bad Lands, including the bar at the Arnold Block. It was presumed that he had fallen in the river while crossing the C> Bridge. Only $5.20 was found on his body.

As New Year's approached, conspiracy theorists began to emerge both in the public and in the newspapers. According to Harrison's widow, Ike had left the house the day of his drowning to undertake a job that would earn him $100. That amount of money was remarkable for most citizens to contemplate. As the *Battle Creek Daily Journal* surmised, "Now if he had a $100 job, it could not have been a legitimate one, as 'Ike' was not a professional nor an expert of any nature, that would rule his services at so high a figure, and the most probable theory was that he wanted to dispose the body of George." The theory was floated in newspapers that Ike had been part of a plot to dispose of the younger man's body and that since "dead men tell no tales, Ike must die."

Further evidence of a possible crime came from June Elizabeth Ryan, better known to authorities as "Libby." Libby was a known drunk and a woman of ill-repute, whose house opened up to the Kalamazoo River. As one report in the *Battle Creek Moon* noted, "Whisky and women were the great failings of Harrison and it is believed now that Ike assisted that night in the removal of George's body from his father's block where it was secreted after the murder and placed in the Kalamazoo River and that he received $100 for the job." While on a binge, she had been arrested and kept muttering that she "did not kill Ike Harrison," which caught the jailer's attention.

Libby's story was that Ike had showed up at her home the night he drowned. He had been drinking whiskey to steady his nerves after "the frightful service he rendered." Libby had seen the money that Ike had been paid. Harrison had stayed with her for a short time and left out the back door, where Libby heard a shadowy figure slug him, take his money and toss him into the river. The only problem with her tale was that it lacked any tangible details, such as the job that Harrison had done and the identity of his alleged assailant. Topping that off, Libby herself had credibility issues. Her drinking and stupors made trusting her a doubtful character at best. In September 1897, Libby finally took a dose of carbolic acid and killed herself, taking with her any secrets that might help solve Ike's murder—if it was indeed murder.

Pump offered a reward for the recovery George's body, twenty-five dollars—less than he had offered for a missing coat and pin. "His continued absence without any clue to his whereabouts had satisfied me that he is dead." To authorities, Pump's behavior struck them as odd. George had disappeared several times in his life, and Pump had never contacted the authorities, yet this time he did so the day after George wandered off. Most parents of a missing child would hold out hope that he would still be alive. Pump was even taking active bets that George was dead. His offers of a reward were paltry, even by the standards of the day. His insistence that the searches for George's body take place at night, by torchlight, with only his hand-picked cronies, seemed ingenuous and deceitful. Something didn't seem right to law enforcement—it was a pattern of strange, almost nefarious behavior.

On February 1, 1895, the body of George Arnold was found by Frank Bauchman under a shed at Clapp Lumber.

THE TANGLED WEB OF MURDER

Adam Arnold has been a holy terror of Battle Creek for the past quarter of a century and feared by its citizens. In the near future he will get his just desserts. There can be scarcely a doubt that he killed his son George by choking him to death.
—Battle Creek Moon, *April 4, 1895*

It wasn't Pump Arnold who was originally arrested for George Arnold's murder. John Edmund Leek, who had worked for Pump since the previous year, was arrested and charged with George's murder on February 5, 1895. Pump was interviewed by the *Battle Creek Moon* upon John Leek's arrest and stated that Leek "was a faithful worker and performed his duties well while on the dining car. He did not regard him as an ugly man." Pump also said he did not believe that Leek killed George. In fact, Pump said, "He would be the last person to suspect. Leek is an honorable, trustworthy fellow and a good worker." Pump also went on to say that "the officers may think that he knows something that will lead to something and that is all."

The *Battle Creek Moon* reported, "The colored people about town say that Leek is not a vicious fellow, but on the contrary was always quiet in his demeanor and very gentlemanly. They say he was in the habit of drinking, which was his worst fault."

The prosecutor's strategy was to arrest Leek, get him to turn against his former employer and reveal what really happened to George Arnold and how he ended up under Clapp's lumber shed. The working theory was that George most likely died at the hands of Pump but that his body was held

somewhere, deposited by Leek (and perhaps another local, Ike Harrison) under the lumber shed after the searches for George had stopped. While it was a solid theory, what it lacked were the details and the links that would lead it to Pump Arnold's nefarious direction.

Leek was arraigned before Justice Henry in the afternoon the same day he was arrested. Leek appeared very nervous and kept tapping on the floor with his boot. As he sat facing the judge with his back to the door, whenever it would open he would start suddenly and look around anxiously. When the judge read the warrant charging him with the murder of George Arnold, he listened attentively and breathed very heavily and nervously.

The same afternoon that Leek sat before the judge, George Arnold's funeral took place at the residence of his father on Jackson Street. "There was a large number present, and the words spoken seemed to greatly impress the father, who was very much affected. A large procession of hacks followed the hearse to the cemetery."

On February 8, 1895, Adam Arnold was arrested shortly after nine o'clock in the evening based on a warrant issued from Justice James Henry's court, accusing him of the murder of his son. Deputy Sheriff A.B. Powell and J.P. King found Adam seated at his desk in the Arnold Block. When the deputy began reading the warrant, Arnold looked up in a frightened and excited manner and exclaimed, "My God; has it come to this? Powell, do you carry a revolver?" Powell answered, "I never go without one."

Arnold was arrested peacefully but requested the officers let him stay in his hotel for the night instead of going to Marshall and the jail. They, of course, refused his offer. Arnold went on tell the officers that he thought "it was a pretty hard thing for an old man like me to be arrested who had always lived peacefully and done anyone any harm." He also went on to say, "This is terrible. I wish I was in old George's place." On the way to jail, the man who never drank liquor insisted on stopping at the bar for a cold beer. Deputy Sheriff Powell did not allow Arnold to have his beer, as no county officer is allowed to let anyone drink liquor while in custody. Arnold spent his first night in the jail, pacing and talking to himself. He was able to sleep for short periods but woke up with a nervous start each time.

The arrest caused a sensation. Not only was Adam C. Arnold "a wealthy and influential citizen," but it was also due to the fact that a father was arrested on suspicion of murdering his son. Murders were rare in Calhoun County in the era, with only one to two per year and rarely one with premeditation. The Detroit, Chicago, Kalamazoo and Iron City newspapers sent their reporters to Battle Creek to cover the trial, adding to the sensational atmosphere of

the pending proceedings. Battle Creek and Pump Arnold were news that were covered as far away as Rome, New York. George Arnold had more fame and notoriety in death than he ever had in life.

At first, no extra comforts were awarded to Adam Arnold. He was treated just like any other prisoner. Officers found money in every pocket that he had on his person. After he was locked in his cell, he hopped down on the bunk and rolled himself in his blanket to hide his head. He lay quietly until the next morning. In the morning, he complained of the place being too cold, even with a fire being maintained all night. Arnold refused to eat breakfast and said that he wasn't hungry. Pump was the most celebrated prisoner in the Calhoun County jail, and the newspapers printed almost daily what he ate, what he was reading and so on. Arnold showed no sign of disliking the notoriety; in fact, he seemed to relish it, giving quotes for publication at the drop of a proverbial hat.

Before being arraigned, he was given an opportunity to consult his counsel, Fred M. Wadleigh. The conference between the two lasted only a half hour. Upon being brought before the justice, Wadleigh said that his client waived the reading of the warrant and asked

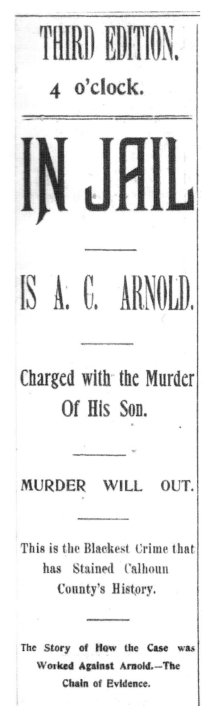

THIRD EDITION.

4 o'clock.

IN JAIL

IS A. C. ARNOLD.

Charged with the Murder Of His Son.

MURDER WILL OUT.

This is the Blackest Crime that has Stained Calhoun County's History.

The Story of How the Case was Worked Against Arnold.—The Chain of Evidence.

Pump Arnold's arrest was big news in the city. *From the* Battle Creek Moon, *February 8, 1895.*

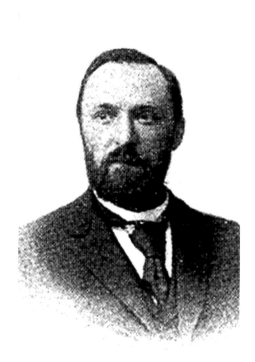

Fred Wadleigh, former prosecutor, pressed Arnold's defense. *Author's private collection.*

for an examination. Wadleigh asked the justice what his idea was concerning bail, to which Justice Henry replied, "I cannot entertain the idea of bail." During his appearance before the court, Pump continually fumbled with his plush cap and scarcely raised his eyes while answering questions. "He did not have the reliant air that has always characterized him in court on former occasions, but acted as though his confidence and pluck were at a very low ebb, and that he feared the result." Bail was rarely set in murder cases in Victorian-era Michigan. The thinking was that if you released a potential murderer back into the community, he or she might influence or even remove witnesses.

Arnold requested the sheriff accompany him to the City Bank. Together with Deputy Sheriffs Powell and King, he crossed the street to the bank, where he deposited the money found in his pockets. The money consisted of at least six gold fifty-dollar pieces. The next day, the sheriff was chided for not allowing the old man to have beer in jail, which Sheriff Walkinshaw pointed out was not allowed for any prisoners.

The prosecution took two and half days to select twelve jurors, and in doing so, the lines were drawn for an epic legal contest destined to make history. H.E. Winsor and T.E. Barkworth of Jackson joined the defense team of Adam Arnold, truly a dream team. Most murder trials only had one defense attorney, but Arnold employed three, including Wadleigh. Frank W. Clapp assisted Prosecuting Attorney Clark. The jury in the case was composed of the following citizens: David Smith, Frank E. Smith and Joseph Bosserd of Marengo Township; James Osborn, C.P. Belcher, C.C. Martin, H.B. Farley and Clarendon D.V. Aldrich of Albion; C.A. Falling of Tekonsha; Thomas Martin of Athens; and Willis G. Blue and Clarendon Jacob Miller of Marshall. The prosecution was careful and deliberate that

no one from Battle Creek would be part of the jury, ensuring no undue influence on the part of Arnold. The defense allowed this, most likely fearing that his reputation in the city could only work against him.

On Wednesday, February 11, 1895, Prosecuting Attorney Clark opened the trial for the people of the State of Michigan at 4:00 p.m. in the afternoon. The first witness sworn in was Frank Bauchman, the man who had discovered the body of George Arnold under Clapp Lumber's sheds on the bank of the river. He was working for L.B. Clapp at his lumberyard. Bauchman did not typically go under the floor of the sheds and had not been under the sheds for at least a year prior.

Orange Scott Clark, prosecutor in the George Arnold murder trial. *Author's private collection.*

On the morning the body was discovered, Bauchman heard a sound like that of fluttering of wings (like a turkey) and thought it was a turkey that had escaped from a neighboring meat market. He pulled up a plank to see if the fowl was there. He then saw the frozen body of George Arnold.

Deputy Sheriff Powell testified that George was lying on his back, frozen in ice to his hips. George's eyes and mouth were open. There was not much water noted on George's face and in his nose and ears. This indicated to Powell that the body had not been floating with the current of the river to the position it was found in but rather was placed there by "a human agency." Powell also testified that the back of the coat George was wearing was wrinkled, as though the body had been shoved along after being deposited on the bank of the river.

Deputy Sheriff King also testified along with Powell that he assisted in chopping George's body out of the ice. Both men noted that they noticed peculiar markings on George's throat. They both reported that the markings, four on one side and one on the other, appeared to look like finger markings. There was also a noted bruise on one cheek.

John Mykins, the undertaker who had prepared George Arnold's body, was the next to take the stand. In an era before criminal forensics, undertakers were considered expert witnesses, given their in-depth experience with dead bodies. Mykins testified about the marks found on George's throat, as well as the bruises noted on his shins and cheek. The undertaker also stated that about a month before George's body was found, Adam Arnold came to his store and asked him to take care of George's body as soon as it was found. Pump made a comment to Mykins that it was his positive belief that the body would be found in the river.

The defense team asked for and received permission for a couch to be brought in for Arnold to rest on. It was a calculated move, an attempt to make the older man appear too feeble to have killed his son. The problem with the strategy is that Pump himself was far too energetic to make the ploy feasible. He rested at times on the couch, but at other times he would explode at witnesses or his own attorneys. It almost added a comical atmosphere to the courtroom.

During Mykins's testimony, Adam sat up on the couch and said, "I don't see what Mykins wants to swear against me for. I always used him well." T.E. Bankworth requested Arnold "shut up." Adam listened and stretched back out on the couch again.

Mykins also stated that a red pocketbook containing a certificate of deposit for seventy-seven dollars and other papers were found in the backside pocket of the coat George had been wearing. The certificate had not been ruined by water, as the writing was clear and legible. The certificate was later paid by Adam C. Arnold to the undertaker to pay for George's funeral expenses.

Dr. Gillette had assisted Mykins in the examination of the body in a room of the Morgan Block. He took the witness stand and testified that George's mouth and eyes were fixed open; Arnold's eyes were sunken and devoid of any natural expression. There were dark bruises under the right ramus of the lower jaw. Three slight bruises were noted on the left side of the median line, irregular in shape, below the cartilage and over the windpipe. Both shins had a black-and-blue spot, and there was a bluish bruise just below the kneecap of both knees. The bruises on the body were made either at the time of death or within a few hours after. Upon removing the scalp to examine the brain, a large spot was found beneath the skin, covering the center of the back side of the head. No cause of death was discovered in the brain. It was noted that the side of the heart and the right auricle leading to the lungs from the heart were distended with dark venous blood, leading to the conclusion that the cause of the death was some means by which

respiration was suspended or breathing stopped. This condition might be produced from drowning, hanging, smothering, inhalation of coal gas or illuminating gas or choking. The fact that no water was found in the lungs led drowning to be ruled out as the cause of death. From the marks on the throat, Dr. Gillette and Mykins concluded that George was choked to death.

Pump fell back to his old ploy of attempting to wage his case in the press. He made another statement to the *Battle Creek Journal*, hoping to garner some public sympathy:

> *The circumstances connected with George's death appear tragic, and the thoughts of them being painful, are more actually so to me, he being my only child. But his fate was such as I could not foresee or prevent, and I have nothing to reproach myself for. I know if George could speak to me, he would say: "Father, be comforted. Indulge in no gloomy thoughts or feelings which will interfere with the usefulness of your own life. You have duties and opportunities for doing good to see in life's hard struggle. I am now free from earth's tribulations. The weakness, errors, pass-ons, and appetite that led me astray, will no longer be repeated or vex me here."*

It was a far cry from saying he was innocent—only that he "had nothing to reproach myself for."

Adam Arnold appeared bright "for an aged person" during the opening session of the trial. His face appeared to be worn and sickly pale, as he appeared to be impatient for the trial to commence. He didn't remove his overcoat when he took a seat. During the afternoon, he reclined back in his seat with his body forward and his face buried in his arms. At other times, he napped. He appeared utterly indifferent and did not even seem to be paying attention.

Adam Arnold was called to the stand on February 13, 1895, and opened with a summary of his life:

> *I came to the City of Battle Creek in 1857 and have resided here ever since; deceased is my son, he was 34 years of age the 18th of February last. He was unmarried and made his home with me with the exception of two years while he was away at school and two years in Livingston, Montana. He has made his home with me this last time some eight or ten years.*
>
> *My wife died two years ago the eighth or ninth of August. Since her death, Fred McDonald has been my mainstay as housekeeper; I have continued my residence at the house 100 West Jackson Street sleeping at the block. George slept most of the time at the house when not at the block. During the last*

two or three months previous to his disappearance, he slept most of the time at the house, once in a while at the block. I do not think he slept a night a week there; sometimes when it was bad weather, I would say George… you had better stay here and sometimes he would do so.

Justice Henry, who presided over the most sensational murder case in the history of Battle Creek. *From the* Battle Creek Daily Moon, *May 6, 1895.*

The fact that there was no school in Livingston, Montana, slid past the prosecution, but it does give a glimpse into the validity of Pump's testimony. Prosecutor Clark pressed Pump about the details of his relationship with his son:

About the last week or ten days, he was in the block most of the time. He was very sick failing very fast and he was very weak. His mind was not right; he was delirious at the time and he was irritable. This increased toward the last week or ten days. He was very good and never gave me a cross word. During the week, there was a night he was very sick. I became alarmed and thought he was going to die he was so delirious. I called a man from the fourth story to go down and have John come up so as not to be alone. I think that was Tuesday or Wednesday night; John [Leek] came up about a half past one and stayed the rest of the night. I think I had some trouble with him the Saturday night before he disappeared. I said I want you to go home with John; Fred can take good care of you there.

On the witness stand, Arnold reflected on the evening of his disappearance:

We often had words sometimes I would make him mind; I had no trouble with him on Sunday, the day he disappeared. I don't remember what hour it

was he called my office, but he was there when I went to supper. I wanted him to go up to supper and after I came back from supper, I said John has come after you, you had better go up. He said he would rather stay. I said you had better go and he said I won't go. I don't know whether we had any more words than that or not.

Pump was then asked by Prosecutor O. Scott Clark, "Now didn't you on this Sunday afternoon between three and four o'clock or about that time, have a disturbance there with him in your office, in which you had an iron rod or poker and he had a stick about the size of a broom stick and didn't you strike or strike at him with this poker or iron rod?"

"No sir, not that Sunday. He was a good boy all that week," replied Arnold. Pump's answer left the packed courtroom with the impression that on other weeks, using the poker on George had been a clear option for the father.

Sensing an opportunity, Clark struck like a cobra: "Did you on any other Sunday?" Unabashed, Arnold responded:

Yes I did; he did not want to go home to supper as he did not like Fred; Fred wouldn't have Effie [Mead] in the house. He said if I go home, I will not stay there. He made the remark that he would go to the house but would not stay just as he was going out of the door with John. I don't know whether he had been drinking that day or not, but I think not. I remained in the office; I do not know at what time I went to bed but it was before midnight. John called me in the morning usually a little after daylight. He called me that Monday as usual. I did not ask about George as I supposed he was at the house. The first information I had about George was when I went to breakfast. I looked around the house to see if I could find him. The window was open right out on Buechner's yard. There was no fence and one of the Buechner girls said she saw George standing in their yard looking into their window about half past nine, when they came home from town.

Pump appeared very much affected during his examination; he wept frequently and broke down several times. Arnold was asked to step down as the prosecutors shifted their focus, crafting how Arnold may have misled others into false searches for George.

A few witnesses took the stand regarding Pump telling them about the disappearance of his son, George. Fannie Brown, who had roomed at the Arnold Block for the past two years, first heard of George's disappearance on Monday night, December 17. She claimed that Arnold told her as she

was coming up the stairs from work. Pump asked her and another woman, Mattie Sen, if they had seen George about the depot. They told him they hadn't. Arnold didn't say much more to the women but did mention it was strange George had disappeared. Ida Sellers, who had roomed at the Arnold Block for the past six years, also heard from Arnold on Monday morning that his son was missing. She had passed Arnold's office on that Sunday night and heard the father and son quarreling. She also said another man she didn't recognize was present in the office during the argument. She heard Arnold tell the man to get a policeman for him, and the man said he could get George quiet himself. With her testimony, the court adjourned for the evening.

The next day, February 14, 1895, testimony continued under Clark's cool hand. The first witness called was Charles Foster, who belonged to the Battle Creek Fire Department. Foster said that he saw George Arnold in the engine house at about nine o'clock on the evening of his disappearance. His testimony was commonplace, relating George's visit to the station and his puzzled behavior while there. He disclosed the fact that George was laboring under a mental cloud that made him act queerly and talk irrationally. George apparently did not realize where he was, although the engine house is on the street on which he lives and he was known to have been familiar with the locality for years.

Next on the witness stand was Arthur Spells, a watchman at the Michigan Central crossing on Maple Street. Spells claimed that he saw George at about 11:00 p.m. the night he disappeared. Spells claimed to have overheard someone shaking the gate that encloses the depot grounds. He found George going through the gate and called over to George to remind him that opening the gate isn't permitted. Later, Spells saw George walk from the train depot and pass south on North Jefferson Street in the direction of Main Street. Prosecutor Clark contended that Arthur Spells is thought to be the last person to see George alive other than his murderer.

Fred McDonald, the somewhat mousy, effeminate housekeeper at the Arnold home on West Jackson Street, took the stand next. McDonald testified regarding George's behavior on the Sunday he had disappeared. He was asked if George drank much and replied that George was in the habit of diluting alcohol with water "for a home beverage." McDonald testified that he didn't remember much of that Sunday but did recall that the Arnold home seemed "usual" on the Monday following George's disappearance. During Fred McDonald's testimony, Adam Arnold sat at the table near the coroner and sharpened pencils, paying casual attention to the proceedings. To those

Main Street view, 1870. *Author's private collection.*

in the courtroom, it seemed that Arnold was detached, unconcerned about anything that McDonald might say.

Pump Arnold called the *Battle Creek Daily Journal* that evening and requested an interview, most likely hoping to sway public opinion about him and the case. During the interview, Pump had "tears in his eyes and his voice shook with emotion" when he talked about the death of his son. He spoke of the goodness and politeness of George "when he wasn't under the influence of liquor" and that George "was honest and square in his deal, and never wronged me out of a dollar although he had ample opportunity to do so." Arnold also went on to tell the *Journal* that the sheriff's office was getting forty-five cents for each witness subpoenaed. He also addressed a rumor he heard regarding George recently inheriting a large fortune: "That is false; George inherited money from his grandfather, but this was a long time ago. George, at the time of his death, had property valued at $1,000."

Pump Arnold continued with his own theory of how events played out: he "believed his son was captured by several men and was objected to being a prisoner and fought with his captors. During that fight, he was choked and hit on the head and his physical condition was such as that a slight shock proved sufficient to cause death. The assassins kept the body until an opportunity presented itself and then put it in the river, where it was found."

Oddly enough, this seemed very close to the theory that Prosecutor Clark was laying out—sans the kidnappers/assassins.

The following morning, Mike Miller, who worked for Arnold as a carpenter and lived at his home on Jackson Street, took the stand. Miller's testimony was important to Clark's case since he had witnessed several fights between George and his father. "They used very hard language and on one occasion, George knocked his father down with a chair and the old gentleman hollered for help." In that particular incident, Miller called for Leek to help break up the fight. "Arnold went and got a strap and asked him if he would behave himself and George said he would not. He struck his father and his father hit him several times with the strap. I went between the two and received as much punishment as George. George finally promised to behave himself and that ended that row. I did not know what started the row, but it was about business downtown." Miller also went on to speak about McDonald: "George had some trouble with the housekeeper, McDonald, but I don't know what it was about. They did not get along well together." One must wonder how George felt with his father all but adopting McDonald as his "son."

Miller also explained what he witnessed on December 16:

> I slept in the house and would have known if he was there. He [George] only slept at the house two or three times the last month of his life. He was at the house the last day and said his father did not want him at the block any longer. I only saw him in the evening of that day at about 8:30. George told me he was brought there but did not say who brought him. There was no trouble between George and McDonald that night that I heard. George did not eat any supper, as he told me he had been [called] to supper.
>
> I first heard of George's disappearance on Monday morning when McDonald told me of it. He thought he had gone back to the Arnold block. McDonald told me George was gone and to go look for him and hunt him up. After we ate breakfast, we all went round to the side of the house and saw where he had lowered himself from the window. At noon, Arnold said he had searched all over the block and George wasn't there and thought he was in the millrace. He said he thought he was thrown in the millrace. Leek said on Monday morning that he brought him home the night before and said he was in bad shape. I heard Arnold speak of getting postcards printed to send out looking for George.
>
> I helped in the search for the body. I went along the Kalamazoo River where Mr. Arnold sent me to go. I asked Mr. Arnold if he wanted me to search at Clapp's Lumber Yard and he said that Leek and Joe all had

searched that all over for two days and George was not there. On Christmas night, the boys went along the river in a boat and claimed he was not under the shed. Arnold said the boys did not half search the river, so I went along there myself but could see nothing. I know where the body was finally found, and when we were there at about Christmas time, we looked all along where the body was found and there was not body there.

If Miller's testimony moved him at all, Pump didn't display it in court. That evening, the news concentrated on his living conditions during the trial. Adam C. Arnold was reported to be "the most comfortable prisoner in the county jail." He had a number of rich rugs sent to him from his store on South Jefferson Street, so that his room had a cheerful and home-like appearance that would distinguish it from the rest of the cells in the jail. The *Battle Creek Daily Journal* reported this about Arnold's extra comforts: "He maintains a sort of dignified reserve that makes him the aristocrat of the motley crowd who are his fellow boarders."

Arnold's trial elicited a great deal of attention with the citizens of Battle Creek. For Victorian-era Battle Creek, this was not just a murder trial but also a form of entertainment. The hotels in Marshall and Battle Creek filled with those traveling in to get a seat during the trial. A crowd constantly hung around the office of Justice Henry, and he barred even the reporters from gaining entrance to the courthouse to give the local citizens a seat. The hallway leading to the office door was also full of people, with the crowd oftentimes noisy. At certain points, the audience was asked to leave in order to make room for the witnesses or attorneys to enter the chambers. One afternoon, as Arnold got a haircut and shave at a local barber, a crowd of at least 150 peeked into the barbershop just to catch a glimpse of him. Arnold made a half-joking comment about the crowd: "We should sell tickets." An almost circus-like atmosphere swirled around the trial, fueled by stories of Pump's devious and vicious business and criminal dealings.

Joseph Sager, an acquaintance of George and Adam Arnold, was called to the stand during the next session of the court. Clark intended to show how Pump's orchestration for the search for George had been a sham. Sager testified, "I looked for the body of George at Mr. Arnold's request. I helped draw the water out of the race." Sager said that he was familiar with the search site and that, during the search, he had looked where George's body was afterward found and that it was not there during their search. To those in the court, it laid the foundation for George's body being deposited

there long after the search. Pump reported to a *Journal* reporter after Sager's statements and claimed that he did not understand why he was arrested and that he wished to have the case thoroughly investigated. Arnold appeared cheerful and unconcerned.

John Leek was discharged from jail on February 19. Not enough evidence was found in order to convict him of any involvement in the crime. A number of friends showered their congratulations when Leek was released, Pump Arnold being among the first to shake his hand and tender his congratulations. Although he was released from the murder charge, much talk around town loomed over whether Leek had helped hide George's body before it was found in the river. Speculation swirled among Battle Creek's citizens that Leek had been freed under the promise to testify against Pump. Perhaps, at last, the kingpin of crime in the city might be forced to face justice.

John Gould was sworn in on February 19 and testified as follows:

> *I reside in this city; have been here eight years and am acquainted with the defendant. I have known him by sight for nearly twelve years. I knew his son, George, and remember his disappearance about the middle of last December. I learned of it on the 17th of that month; I talked about it with Arnold and he wanted me to look for him. I looked in Larkins' barn and all the empty buildings. I went to Clapp's shed and all through them until I struck the Main Street Bridge and then back to M.C. Depot. I was alone; I examined both sides of the river between West Main Street and Union Street bridges, looking closely through the cracks of the floors of the buildings projecting over the water. I looked until the tile place where the body was found but did not see it there. Think I would have seen it if it was there. I made a second examination there the day after the water was drawn from the race. I looked all along where the body was found; I pulled the lumber aside and saw nothing. That afternoon, I went and searched the river thoroughly at the Angill Bridge. I did this at Arnold's request. I had a talk with Arnold and he said he had offered a $25 reward for the body. I said let me have to keys to your building, I will look there. He said "he ain't there, I have looked there." I made no other searches for the body after this.*

Clearly the prosecution was laying the foundation that George's body had been planted under the Clapp Lumber shed long after his death, at Pump's direction.

Toward the close of the afternoon's trial, Mr. Clark expressed a desire to have the jury visit the scene of the alleged murder at Battle Creek on

Friday morning. Both of Pump's lawyers objected to having the jury inspect the Arnold Block. Pump sat feebly up on the couch and was all ears while his lawyers argued. Judge Smith decided that it was best to postpone the proposed excursion for at least a few days.

No one realized the identity of the sensational witness about to called: George's alleged betrothed, Effie Mead.

A WOMAN SCORNED

"Pump" Arnold, now under arrest here on suspicion of having murdered his son, George H. Arnold, is one of the most picturesque old men in Michigan, and yet there are some things about the man that inspire pity and convince one who has devoted any attention to the case that he would not intentionally kill his son, though it would be different if anyone else opposed him as much as George did. The old man had an ungovernable temper, and when he did not curb it something must drop.
 –Battle Creek Moon, *February 11, 1895*

Prosecutor Clark produced his bombshell witness on February 21 in the form of a somewhat fallen flower named Effie Mead. Mead had alleged to have witnessed the attack that killed George Arnold, her betrothed. While her story was not without flaws, it was seen as the finishing nail in Pump's legal coffin.

The mawkish Mead began her testimony to a hushed and packed courtroom as a late February snow fell outside the Marshall courthouse:

I have lived in Battle Creek since a year last November, most of the time at Mr. Arnold's. I went there Nov. 10th year before last and left in April. I was three weeks in Potterville and then went back to the house; was there from April till Oct. 12th, when I went to Green Street. The 10th of last month went to the Hamblin House, remained there a week or ten days, and then to the Arnold block. I have roomed there ever since. When I lived at the Arnold house on Jackson Street, I was supposed to be one of

Right: Effie Meade, the prize witness for the prosecution who allegedly witnessed George's demise. *From the* Battle Creek Daily Moon, *April 9, 1895.*

Below: The Hamblin Opera House in Battle Creek, the hub of civilized entertainment in the city. *Courtesy of Heritage Battle Creek.*

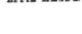

EFFIE MEADE.

the family. The other members of the family were Fred McDonald, Mr. Arnold, George, John Leek and Andy Byers. I have apparently kept up my acquaintance and friendly relations with the family since. I suppose I was George's intended wife; I became engaged to be married to him about a year ago. The engagement was not broken off till his death.

No doubt this caused a stir in court since few who knew George as the town drunk would have thought him capable of maintaining a romantic life.

Prosecutor Clark ushered Effie into a discussion of George's relationship with his father:

During my acquaintance with the family, I did not know of any very severe trouble between George and his father. They jangled once in a while; they had disputes and quarrels occasionally. This depended on how often George got drunk. The quarrels usually occurred on the occasions when George was drunk. He had these intervals of being drunk perhaps the time that I knew. He was in the habit of drinking alcohol to produce intoxication; he got the alcohol at the drug stores. Different parties procured it for him; those were Joe Ash, John Leek, George Morton and several others I don't remember. I have known his father to get alcohol for him three times, in quantities of two or three quarts. The alcohol was kept in a large bottle in George's room. I did not have very much conversation with Mr. Arnold in relation to his furnishing alcohol to George; he thought it might sicken him so that he would quit drinking.

I knew of trouble between George and his father in relation to money which George chimed was due him. George said that the old gentleman owed him some money and they used to have a good many quarrels over it. I heard George ask him for this money several times; Arnold replied that it would probably be fooled away and not be made good use of. I did not know of Arnold's giving George any of this money that he claimed at any time. I do not know just at present of any other cause of dispute between them. George claimed that his father objected to his marrying me; think they had quarrels over that. George claimed that his father had $8,000 that belonged to him; he wanted the money to go into business.

The prosecution narrowed its questions to Miss Mead to those that would get to the heart of the tension between father and son. Her words painted a dark side to life on Jefferson Street:

The disputes between George and his father were at the house and the block. I have not seen them come to blows, since last summer about five months ago. I have known of their having quarrels since. The last one was at the block about a week or so before George disappeared. Mr. Arnold wanted George to go to the house, and he didn't want to go. Arnold wanted him to go because he was sick and would have better care, and he was bothering him. George did not go to the house. I do not know of any other quarrels or disputes about that time; don't remember when the last one before this one. I was not rooming at the block when this one occurred. In the disputes in which they came to blows, I do not know of either having a weapon of any kind, except that Mr. Arnold had a cane and rubber hose. I have seen him strike George with the cane, probably two or three times, over the head and shoulders hard enough to break the cane in two. He kept the rubber hose to lick George when he would get drunk; he did not use this hose very often. I have known of John Leek and Mike Miller holding George, two or three times, while his father was using the rubber hose. Arnold was provoked on these occasions by George teasing and aggravating him. On such occasions George did not fight back, he was afraid. It was in the workshop where his father struck George with the cane and broke it; do not know of the cause of the dispute at that time.

With those words, her first day of testimony drew to a stunning end.

Effie continued her testimony through February 25. According to Mead:

I saw George Arnold on Friday evening before his disappearance, in bed. He appeared very sick and low; his father wished me to encourage George to go to the house. [He] talked with George about it, he refused to go. Arnold once said he had something that would cure George from drinking and that he refused to take it; he [Pump] wanted me to give it [to George]; I did not know the medicine, it was similar to powder. [Pump] Arnold said I could give it in alcohol. I didn't wish to have anything to do with it; this was about a year [earlier]. Arnold said it was harmless and would have the same effect as the Gold cure: [He] never asked me more than this once. [I] do not know whether the medicine was ever given or not; [I] had no reason to doubt Mr. Arnold as to the safety of it or what it was. I did not wish to have anything to do with it. I would have been glad to cure George of drinking, he was sick at the time and I didn't know what effect it would have.

Mead offered another piece of the puzzle as to where George's remains might have been between the time of his disappearance and when he was discovered on the bank of the Battle Creek River:

> After George's disappearance I went down to the block every evening to inquire if Mr. Arnold had heard anything about George. One evening I saw a couple of boxes taken from there: they looked like dry goods boxes, quite large: one was square and the other a little long. [I] should judge the smaller box was as high as that stand and about two times as large. The larger box was the highest and may be four or five feet long. I cannot tell who took the boxes away; John Leek said the boxes were packed with goods going west. It was in the evening, [and] Leek was at the top of the stairs. I did not see Leek assist in loading the boxes on the dray. The boxes were on the steps, and the dray standing in front of the block. I do not know where Arnold was; John Leek said he was down town somewhere.

Pump interrupted her testimony, drawing the wrath of the judge in the process: "You're a damned liar Effie Mead!" he cursed. The outburst was not rare, Arnold had been making comments loudly for days, but it was the first time that his venom showed itself publicly.

Alfred H. Spells was called for examination on the twenty-fifth as well. He claimed to have seen George Arnold on the night of December 16 walking toward Main Street and past Ward's Mill. "When he passed back from the depot, Ward called my attention to his return. I looked out the window and saw him cross the bridge and go by the mill."

Spells had seen more than George the night of his disappearance—he may have witnessed the depositing of George's body several weeks later. Long after George's vanishing, Alfred noticed a boat with a very bright light stay under the bridge for about ten minutes. A train came in, and the boat left the bridge and went downstream. Alfred lost sight of the boat as it passed under the McCamly Bridge:

> When it went down the river, it went close to the Clapp's lumber shed all the way down, probably a rod and a half away. The light they had was burning all the time, and the boat did not stop between bridges. The persons in the boat were Mr. Arnold and another man, but who he was, I do not know. Mr. Arnold sat in the forward end beneath the jack light and the man was in the back of the boat rowing. The other man had an overcoat on and his hat pulled over his face, so that I could not tell who he was as he has his

back towards me. I did not hear either of them say anything and I did not speak to them. I did not call anyone's attention to them. I was standing on the end of the bridge as the boat got to Ward's Mill and watched them. I saw a spear in the boat; I did not see either of the men move around in the boat. I went with Mr. Arnold to see Mr. Ward the next day after George was missing. This was the only time I saw Arnold in a boat in the river. This was the night after the water was drawn out of the race. When the boat was under the bridge, I was leaning out of my window at the watch house. The boat slightly moved around under the bridge. There was no one along the bank with the boat I saw, and I heard no conversation. I did not see anyone on the McCamly Street Bridge or along the banks as it went down.

Harry Earl was the next witness called on behalf of the prosecution. About a week or two before George's disappearance, Earl was in the office at the Arnold Block and offered his testimony of what he had seen there:

George came in and it seemed that he had been away and got some money. I understood him to stay at the Watkins House. He handed Mr. Arnold a number of bills which Arnold counted over and over. He asked George where the rest was and asked if he gave a receipt. He said he did and Mr. Arnold asked if that was all the money he gave him. George said "yes." Arnold told him he lied and that he was a "damned liar." He got really angry and kicked George below the knees. George put his hands down on his leg where he [Pump had] kicked him and Mr. Arnold struck him with his hand and knocked him over. He reached on the shelf and got the hammer and he said he had a notion to knock his brains out if he didn't give him the rest of that money. I was standing by the door and did not interfere. It was none of my business; the trouble was going on for probably five minutes. I made no move to stop it. It was nothing to me whether he hit him with the hammer or whether he didn't. I never heard or saw any disturbance between parties before. I heard of George's disappearance in front of Arnold's block. I came along there and the colored gentleman that works for Arnold came along.

Harry Earl's testimony further dug into Pump's attempts to paint himself as an innocent and loving father.

Prosecutor Clark called John Leek himself to the stand to attempt to further validate what Effie Mead had testified in regards to the box:

Heard some of the testimony of Effie Mead in regard to taking two boxes from the Arnold block. Don't know the drayman who took them away. Mr. Arnold told me they were going out west. Some relation of his, I think, had been burned out and he was going to send them clothes. I first saw the boxes in Effie Mead's room; [they] had been there for over two weeks or more. Think they came from the upper floor and had overcoats packed in them. I brought the boxes down from upstairs. Mr. Arnold ordered me to bring them down. The largest box was about three feet long, probably two feet wide and a little over a foot deep. After the boxes were in the room, I took out the clothes, cleaned them, and left the boxes there. Saw them fill part of them pretty near full. The largest one was full, he nailed it up. He put second-handed clothes, crockery ware, and such things as that in the smaller box. Said he was going to them to parties in Nebraska. I think to some cousin, or something. He told me both boxes were to go to the same place. I helped to carry the boxes down; don't remember who assisted, but it wasn't Mr. Arnold. I didn't mark them and don't know who ordered the dray. I didn't assist in loading them and did not nail the covers on. Think Arnold was eight or ten days in getting them ready.

When asked about his search efforts for George's body, John Leek was remarkably open, considering that many suspected he had played a role in dropping off George's body:

I was up and down the race twice when they were looking for a body. I examined the sewers but didn't go down into the water. [I] first learned that George was missing the next morning, after I got down to the house. They said he had left the house out of a window. I came right from the block and went there every morning to call Mr. Arnold. I called him that morning and he said nothing about George. After learning that George was gone, I went down at Mr. Arnold's request around the hotels and streets to see if I could hear from him. It was over a week, I think, before we looked for the body around the river and block. Looked through all the rooms, think it was at Mr. Arnold's request.

Clark asked Leek about the alleged money that George felt his father owed him, implying with the jury that it may have been part of a motive for Pump to kill his son:

[I] heard George about the money his father owed him; a month or two before. George said one day: "If you will pay me that money you owe me,

I will go into business for myself." George would say this when he was drunk; his father would say "You can have it whenever you want it, if you are right and sober." Don't think his father ever paid him the money. I don't remember whether they were quarreling about this money the week before George was missing.

As if the trial was not sensational enough, it took another bizarre turn when Adam Arnold was finally released from jail on February 27, 1895. Bail was granted for $10,000 with the consent of Prosecutor Clark. The *Battle Creek Moon*'s office was visited by dozens of citizens, all of whom were unanimous in their expression of disgust at the action of the prosecuting attorney on releasing Arnold. The bonds were issued before Circuit Court commissioner L.E. Clawson. The application was made by Arnold's attorney Wadleigh. Clawson asked the prosecuting attorney if there was any objection, and he replied there was none. In securing his bondsmen for the liability of the bail, Arnold gave a mortgage on all his property in the city.

The citizens of Battle Creek, spurred by an editorial campaign from the *Battle Creek Moon*, were fearful of Arnold's release. There were calls to remove the prosecutor from office for putting the population at risk. Even though he was an elderly man, there was palpable fear of what he might do against witnesses or anyone else who crossed his path.

According to the *Battle Creek Moon*, while out on bail Arnold "seemed to be pleased to be at liberty and evidently does not care to have the case pushed now, as it is much nicer than being in jail. The longer the case it put off the harder it will be to find any witnesses who remember anything connected with the case. Others may be intimidated and altogether the longer the examination is adjourned the better for the defendant."

His time in jail had not mellowed the elder Arnold in the least. Frank Bauchman, who found the body of George Arnold, asked Arnold for the reward of twenty-five dollars, which he advertised to give for the recovery of the body. Arnold refused to pay him. He said he was having trouble enough now and did not think that Bauchman ought to ask him for it, as he did not find the body when actively engaged in the search for the same. Bauchman claimed that if he didn't receive payment soon, he would sue Arnold for it. The ten-dollar bet between Arnold and Sheriff Walkinshaw regarding the body being found in the river was also not paid since Pump had bet that his son was indeed dead.

The Arnold case reconvened before Justice Henry on the morning of April 3, 1895. Mike Miller was the first witness called, his second time to

the stand. Miller reported seeing Arnold and George quarrel and come to blows twice:

> *I remember the Sunday evening on December 16th. George was brought home. He always came home himself. I was in the laundry part getting the tire ready for the washing. George was in the room when I came in. I says, "hello, you are here." I asked him if he had been to supper and he said he didn't want any. He told me he was going to stay at the house and said his father didn't want him at the block. The last trouble that I knew of between George and his father was at the time that George kicked Effie Mead out of the house and she came in crying, "George has thrown all my goods out." Mr. Arnold walked in and said: "Here, give the woman a fair chance to get them." George drew his chair and hit his father. He [Pump] called for help, John Leek was on the left hand side and I was called in on the right hand side. Me and John Leek begged George to give up on his father and he continued to hit on him. The old gentleman was pretty careless about hitting; I got more lashing than George did. We tired him out and he finally gave up on his father.*

At the prosecutor's prodding, Miller explained his role in the search for the victim's body:

> *After George was missing, I assisted to search for the body. I was out four days looking; the last time in January. I went from the lower bridge to Augusta and came back on the train. I was out on the night that Williams and the two colored boys were on the river. I carried a pole and the lantern. I examined, at the time, the premises known as the Clapp lumber yard. It was Christmas evening or the 26th. Mr. Arnold said that dock hadn't been thoroughly searched. I went there and searched through the cracks and I couldn't see him. I did not see the place where the body was found. I do not think the body was under the shed as the other parties claimed he was not there.*

Effie Mead was recalled to the stand on April 3 to offer her most damning testimony. The *Battle Creek Moon* did not portray her in a fully positive light, pointing out that she "claims to be 30 but looks 45, is a good looking and well-dressed woman. She wore a black suit and a jaunty Gainsborough hat to court."

Prosecutor Clark knew that her credibility would be at risk, so rather than try to hide certain aspects of her life for the defense to uncover, he exposed

them himself so as to control her past. She began her testimony by declaring that the sheriff had indeed been paying her board ever since she became a witness for the people. The sheriff was paying for Effie's rent and providing protection as compensation for her testimony. For the defense, this was useful. The seed was planted that she was a person who was making money from her role in testifying.

Her past was certainly not helpful for Prosecutor Clark. "Effie, who is married to David Gee and has two daughters (ages 11 and 9) who attend school at Coldwater, left her husband to come to Battle Creek three years prior from Gaylord, Michigan. David and Effie separated two or three times before he finally asked her leave in December 1893." In her attempt to explain her relationship with her former husband, Effie gave differing stories. She had "heard that he went to Canada and died of heart disease" or, as she had told others, that she wasn't sure if her husband was alive or dead. Effie admitted to posing under three different names and had lived with many men since leaving her husband. Upon arriving in Battle Creek, she had no money and inquired for a pawnshop. She was directed to the office of Adam C. Arnold, where she "pawned a gold watch and chain and a dress pattern." To the staunch religious and Victorian values of the community, Effie did not come across as a woman in distress.

While living with George, she saw many fights between father and son. The arguments were violent, almost always involving some instrument. On one occasion, Arnold struck George with a knotted cane and broke it in two over his head. Another time, Pump had given Effie a dollar to buy some medicine. When Effie did not return the change to Pump, he threatened to kill her. Effie also reported that George would often drink about a half pint of alcohol a day, with Pump supplying it for him.

A week before George's disappearance, George had been sick, and Effie stayed at the block most of the time to take care of him. Effie stated that she was with Dell Rowley before she met up with George by appointment the night of the alleged murder. She had not seen George since the Friday before the murder, stating that she was afraid of Adam Arnold. She was supposed to meet with George at 10:00 p.m., but she did not show up until between 11:00 p.m. and 12:00 a.m. Before meeting up with Rowley, Effie informed George of her scheduled "business meeting" and noted that she would be late. Effie explained that the meeting with Rowley was to collect the remaining fourteen dollars he owed her. Effie went on to explain that George got jealous when men paid her attention but did not mind her speaking to men as long as he knew she didn't care for them.

After they met up, George had to pass through his father's office and bedroom to get to his own room. She stood at the bottom of the stairs, about fifteen feet away from the open door of the office. Father and son swore and called each other vile names, and Arnold kicked George on his shins. After more arguing, George grabbed a stick, and Adam grabbed an iron poker. Arnold knocked the stick out of his son's hand and struck him with the poker three times, once on the shoulder and twice on the side of his head. George fell to the floor, and Adam fell on top of him. The struggle continued.

George cried to Effie, using her nickname, "Bess! Bess!" and then cried out to his father, "For God's sake, don't kill me!" George cried out "Bess!," and then all was quiet. Effie ran downstairs, extremely frightened. On the street, she noticed a man in a greatcoat, who was apparently listening to the struggle. Arnold came down and was talking to the man. A moment later, they both went upstairs. Effie claimed that she never saw George after that night.

The prosecution did not let up but instead went for details that might further implicate Pump in his son's demise. Effie stated that she saw Adam gripping George's throat, while George cried, "Don't kill me, father." Adam, realizing his son's fiancée was a witness, reportedly threatened to shoot Effie if she told anyone what she had seen. Terrified for her own life, Effie ran from the Arnold home. Effie had not reported anything to police until George's body was discovered with markings on his throat. She claimed that she did not report anything to police because she was afraid of Pump. However, she had many talks with him after George went missing. Pump even told Effie that George must have fallen in the river.

The bombshell had been played for the jury. Effie Mead had witnessed the murder of George Arnold by his father. Mrs. Roach, who Effie had been working for at the time of the alleged murder, was called by the defense team to refute some of Effie's story. She testified that Effie came in at about 1:30 a.m. on the night of December 18, 1894. Effie told her boss that Arnold had accused her of stealing a diamond ring, and she declared that she would "get even with the old fool." It wasn't much in the way of testimony, but it was intended to cast doubt into Effie's motive for testifying.

The defense team called up a long string of witnesses to attempt to erode Effie's character. At least one of those, Adelbert Rowley, proved on the stand that he had taken money from Arnold for his testimony—doing more damage to the defense's cause.

Effie was recalled again, this time weaving a tale of blackmail on the part of Pump. When Adam was out on bail, he gave Mead money and his note

for $100. Effie claimed that a man named Ryan returned her a gold watch and chain that were pawned to Arnold, and Arnold had stated that he had given the ex-sheriff Prentice money to give to her. Arnold also offered her a room in his block and promised to support her for life if she would not swear against him. He told Effie that "she held his life in her hands." If she did indeed witness the murder, that was likely the most truthful thing that Pump had said in regards to the murder.

According to the *Daily Chronicle*, Effie kept her cool and answered all questions asked during the cross-examination. She never once contradicted herself. As she sat in the witness chair, she wore an elegant gold watch, chain, diamond ring and an emerald ring that had belonged to George. Effie explained that she had not told anyone about what she had seen that night until the trial. Her testimony would be corroborated by other witnesses who overheard Adam make great offers and promises if she would not testify against him. During Effie's testimony in court, Adam became so enraged that he was difficult to restrain in the courtroom. Effie was so unnerved that the court had to take an adjournment.

At 10:00 p.m. on the evening of Effie's damning testimony, John Leek appealed to police to lock him up in a jail cell, as he was afraid Adam Arnold would kill him. Leek stated that Arnold threatened his life and had also offered another party $100 to murder him. Leek appeared to be under the influence of liquor as he made his pleas, but officers still locked him up as he had requested. Adam appeared to be looking around for Leek the next morning and appeared anxious. Leek, who appeared sober the next morning, declined to be let free from jail and asked the officers to continue to keep him locked up for several days.

According to the *Moon*, John Leek believed that Pump was going to have him murdered. Leek explained that Arnold had a man come to Battle Creek from Chicago to be a witness against him. Leek stated to Justice Henry that he had not told all he knew about the Arnold murder when he was on the stand, and he wanted to tell the whole truth and "clear his mind." According to the *Moon*, Leek told the reporter "many things that it is not best to publish at present until they come out in court."

Other witnesses corroborate Leek's story about seeing another strange man in consultation with Arnold. According to the *Moon* account, "The sheriff has his eye on everybody who works for Arnold and helps him in his nefarious schemes needs watching." The sheriff reported that he seemed pleased over what he has found out from Leek and stated that the evidence was getting stronger every day.

When the trial resumed on May 1, 1895, Effie Mead testified that Pump had told her that he would kill or hire someone else to kill anyone who had testified against him. He also told Effie that he had been in a "good many scraps" and had always gotten out of them and that he was too old to be caught now. Adam exhibited a loaded revolver that he had with him and said that he was going to carry it with him to the courtroom. He then threatened to shoot anyone who testified against him and then shoot himself. The prosecution was confident in being able to convict Adam Arnold. Effie Mead's testimony was golden evidence against Adam Arnold's brutality. The defense called for adjournment to confer with its client. For the time being, Arnold's release on bail was rescinded, much to the relief of the witnesses.

A few days later, on May 10, Adam Arnold walked into court "acting like a man who had lost all hope and was broken hearted," according to the *Marshall Statesman*. "After being enraged in court for weeks, he seemed to have lost his bravado and seemed to realize the end of his freedom was nearing. After selling almost all of his real estate and personal property in order to pay for the trial, it was reported that he would only be left with $10,000 of the reported $150,000 net worth."

Fred McDonald and Pump's brother in-law, Ira Daggert, went to Marshall on May 24 to visit with Arnold. They took along a music box for Arnold to amuse himself with and pass the dull hours in his cell. Daggert was the only family member to visit Pump while in jail.

The trial took an intriguing twist when the husband of Grace Eschbaugh, the young woman whom Maria Arnold had taken as a foster child, turned up in the courtroom. He refused to speak with reporters and only sat through two days of testimony. Grace herself didn't visit her stepfather, but there was talk that she might be appear as a witness as to the relationship between George and his father.

The prosecution, sensing that the defense might claim that George had simply drowned, brought in an additional witness to bolster that aspect of its case. Dr. Edward Wert Lamoreaux of Battle Creek testified to the condition of George's body at the postmortem examination. No water was found in George's lungs. One lung was filled with dark, clotted blood. The blood vessel leading from the right lung in the heart was filled to bursting with blood. There was no mud or foreign substances of any kind in George's mouth or lungs, which would have happened if he had been resting on the river bottom. His stomach and intestines were nearly empty, indicating that George had not eaten for several days before his death. There were heavy blood clots around a severe bruise on the back

of his head, and his brain's veins were all distended with clotted blood. Dr. Lamoreaux stated, "From affections of various parts of the body as observed at the post mortem examination, and marks on the throat, it is in my opinion that he came to his death by extreme violence applied at the throat, as by a person strangled." While Dr. Lamoreaux gave his testimony, Pump was wide awake and very alert.

Dr. Lamoreaux also testified that there were no wounds near George's right temple. This testimony was in conflict with Effie Mead's testimony that Adam struck George twice over the right temple with a stove poker. Dr. Lamoreaux concluded that he did not think George's body was exposed to the elements for a week after death. This caused many to speculate where George was kept in the period between his disappearance and the moment when his body was found.

The defense recalled Adam Coroner Gillette to attempt to point at the differences between his testimony and that of Dr. Lamoreaux. This attempt was marred by Pump himself when he interrupted his own attorney during the cross-examination just to ask for another glass of eggnog. Adam's attorney Bankworth yelled, "Keep quiet!" to his client. The sheriff's deputy did end up bringing Adam another glass of eggnog. The red-faced Bankworth had to wait until the audience had finished laughing and then proceeded with questioning. The long trial was taking a toll on everyone.

W. II. Conkling, a carpenter who had done many jobs for Arnold, testified that he had known Pump for twenty-five years and George for fifteen. He had personally witnessed many fights between the father and son in Adam's office. Conkling testified that two years earlier, he had visited Adam's office on business. Adam and George were fighting, and Adam kicked George on his shins with heavy boots. George was calling

A. C. ARNOLD.

Pump Arnold during his trial. *From the* Battle Creek Moon, *May 6, 1895.*

Adam names and was "somewhat intoxicated." George had been sitting in a chair when Adam kicked him eight to ten times. George said to Conkling, "What do you think of that, Conkling, for a father?"

A few weeks after that fight, Conkling testified that he witnessed another fight between the father and son. "When I came in, they were swearing and the old man was poking the fire. Arnold said 'damn you, I ought to have killed you long ago.' And raised the poker to strike."

Lemuel Ulrich, a cook and sometimes carpenter, had occupied rooms in the Arnold Block for two weeks before George disappeared. He was at the block on the Sunday that George came up missing. That Sunday afternoon, Ulrich stood at the head of the stairs and saw Arnold pounding vigorously on a table in his office. Arnold shook his fist at George and appeared to be storming at him. Ulrich heard George say, "You know you owe me the money and why don't you pay it back to me?" Arnold then grabbed an iron poker, and George grabbed a broomstick. The old man struck his son in the back of his ear and knocked him down. Ulrich stated that he later saw George on the block later that day. Unfortunately, his testimony was further tainted by his own involvement in the alleged witness tampering earlier in the trial.

The stalwart and faithful John Leek, the colored man who was originally arrested for George's murder, swore to having witnessed many fights between the father and son. After George disappeared, Leek searched for the body in the river and millrace and even at the very spot where the body was found. The body was not there when Leek made his search. Leek had heard Arnold offer Effie money. Once, Arnold had even given Leek ten silver dollars to hand to Effie to keep her quiet, saying, "The damned woman was raising hell." Leek refused to give the money to Effie. Whatever his involvement was in covering up the crime, he apparently drew the line at paying hush money. Despite his earlier words to the *Battle Creek Moon*, this was the extent of his testimony.

The defense team devoured Leek, portraying him as a drunkard and a poor employee, as well as somewhat vengeful of Pump Arnold. They tore into his credibility, and Leek's response did him no favors with the jury. For a while, Pump was getting his money's worth from his defense team.

Pump's character was deeply tainted when Battle Creek chief of police Elliot swore that Arnold had offered to bet $50 that the body was in the river. Sheriff Walkinshaw also swore that Arnold offered to bet him $100 that George's body would be found in the river. The sheriff staked $10 that George would turn up alive. Eyes in the courtroom drifted to Arnold and

saw a man willing to bet on the death of his son and where the body would be found.

The defense team mounted its most impressive attack on Effie Mead when it pressed for a visit to the Arnold Block, the alleged murder scene. Using Effie's own description of where she stood on the stairs and what she allegedly saw, the jurors found some of her testimony drawn into question. From where she claimed to be standing, it would have been almost impossible for her to have witnessed the attack on George, as she described it. To the reporters who covered the case, there was a palpable fear that Pump Arnold might once more escape justice as a result.

After three hours of deliberation on December 26, 1895, the jury in the Arnold case reached a verdict: Adam Arnold was guilty of manslaughter. Pump went from smiling when the jury walked into the room to tears as he remarked, "Oh my god," after hearing the verdict.

Mr. Bankworth asked how many of the jury members had subscribed to the *Battle Creek Moon* during the trial, and with one exception, they had all ordered the paper containing an account of the trial. Judge Smith asked if they actually read the *Moon* during the trial and was informed that they had not; the papers had been sent to their families instead.

There was no demonstration in the courtroom when the verdict was announced; even the judge had a surprised look on his face. It was not thought possible that such a verdict could be agreed on; few even predicted an outright disagreement among the jurors. The fact that a manslaughter verdict was reached without evidence and purely based on a man's peer record was unheard of at the time. It was even rumored that one juror remarked that he had already made up his mind on the first day of the trial. Several of the jurors commented that when they had visited the crime scene, they saw flaws in the testimony that Effie Mead had given. Her view of the attack that killed her beloved George was not feasible when they stood on the stairs themselves. While this tainted her testimony, they felt strongly that Pump had caused the death of George in an outburst of accidental anger.

The public had mixed feelings upon hearing the verdict. Everyone knew how awful Adam Arnold was as a person. There was no denying his wicked personality and his wild ways. But Adam's past is what convicted him of manslaughter in the death of his son—not evidence.

On January 9, 1896, Adam Arnold was sentenced to life in prison for the death of his son, George Arnold. The *Rome Daily Sentinel* reported that Adam became irate with George after George had asked Adam to give him

a lot of land and a home in Battle Creek. George had planned to marry a hired servant, Effie Mead, who worked for the Arnold family. However, the scourge of Battle Creek was far from finished when it came to inflicting vengeance on the city that had betrayed him.

BYGONE

For the past five weeks it has been reported that Adam C. Arnold was on his death bed and a great many stories have been sent out from this city to the city papers about his precarious condition; that he was a physical wreck and that he was bordering upon dementia. The correspondents of the Chicago and Detroit papers were instructed to watch out hourly for his death…There are a great many stories afloat regarding the matter, and many people are becoming of the opinion that his alleged death bed sickness is a bluff characteristic of Arnold.
–Battle Creek Moon, *"A.C. Arnold—It Is Believed that His Death Bed Sickness of Feigned," January 26, 1897*

Anyone who thought that his conviction for killing his son would dampen Pump's tenacity simply didn't know Pump Arnold. In January 1896, while still in jail, his attorneys filed an appeal demanding a new trial. Herman Brand of Marshall said that a juror, Jacob Miller, had told him before the trial that he thought that Pump was guilty. Pump's defense team claimed that Brand's predisposition prejudiced the verdict.

Pump was still in the county jail as of mid-February and granted interviews with the press. As reported in the *Battle Creek Daily Journal* on February 17, 1896:

> *The aged prisoner is glad to have visitors as it breaks the monotony of his confinement; he seems to be more deaf than before his confinement but in other ways he seemed much as he did before his arrest. He, as usual,*

asserted his innocence of the crime for which he has been convicted, and said that his boy George was the apple of his eye. Arnold said that the trail has cost him $3000 so far that he has paid his lawyer $100 a day for sixteen days. He says that he has everything he wants while in jail, and a number of fine oranges that were on the table corroborated his statement.

The old man said that Wednesday the question as to bail would be argued. He seemed to have no doubt but that he could secure bail, his reasons being that he obtained it so readily before. One thing that seems to trouble Adam more even than confinement and conviction is anxiety in regard to the contents of his safe; there were eighty-five watches in it valued at $1,500 and when Arnold was down here with the jury he could not get the safe open: he fears that it has been tampered with and the watches stolen.

Pump's empire was eroding as he stayed in jail. The city council brought up a motion to have Arnold's prized statue of Mayor Gage removed as an eyesore. It was as if they would smell blood and sensed Pump's weakness. The motion was defeated, but Arnold could tell that the wolves were circling. He gave the monument to a friend, Charles Hovey of Centerville, Michigan. The statue, designed to mock the mayor, became an oddity in Hovey's yard, along with a pet bear in a pen. It had gone from a monument mocking authority to being little more than a conversation piece/lawn ornament.

While Pump's close confidant, Fred McDonald, maintained his properties, Arnold was no longer directly managing his affairs from his cell. McDonald was a close associate. He attended to Pump's every need while in jail, bringing him everything from newspapers to a music box to occupy his time. McDonald had been at Pump's side in his business for more than two decades and was the only person Arnold trusted with the key to his office while he was incarcerated.

On February 28, 1986, his attorneys managed to get his bail reduced to $6,000 for the manslaughter conviction against his son. Despite their efforts, Pump himself was unable to **make bail**. As he attempted to arrange for his release, he suffered another legal setback, this time in the case of Mrs. Paulina Hamilton, who had sued him for assault for picking plums that Pump claimed were his.

The property line between Arnold's and Hamilton's lots had long been disputed, and three plum trees were located in a disputed corner. Hamilton claimed that as she and her son were picking plums from one of the trees, Arnold found her with a pan partially filled with plums and grabbed hold of her. It was alleged that Arnold seized her by the arm and jerked her about in

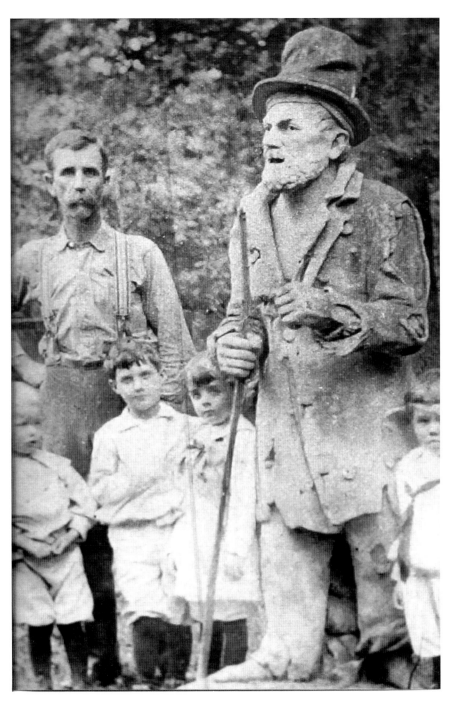

Charles Hovey with the infamous statue of Mayor Gage. *Courtesy of Heritage Battle Creek.*

such a manner as to strain the ligaments and cords near her shoulder so that she could not use the right arm above the elbow. Hamilton alleged that she had prior permission from Arnold to pick the plums. Arnold chose to label her as a thief. In the civil case, a jury decided on a verdict of $1,500 for the plaintiff.

Pump's legal team immediately appealed the ruling, but the cracks in Arnold's usually resistant veneer was starting to show. Rumors began to circulate that his health was failing, but most citizens didn't trust such reports. After all, this was Pump Arnold, a man who had cheated law enforcement and legal authority for the majority of his life.

Sensing his crumbling empire, Pump drafted a new will, with a hint of vindictiveness. Before his signed the will, he transferred ownership of the Arnold Block to Fred McDonald. Within the will itself, he left all of his properties to the Woman's Christian Temperance Union with the stipulation that it provide a suitable monument in the cemetery for Arnold and his wife. He ended the will with a handwritten note:

> *Man's inhumanity to man have through fraud and perjury while helplessly and friendless state and through perjury deprived me of what I had intended for a memorial for my wife for the needy in the discretion of the corporation named. It is my sincere hopes and prayers that my innocence may yet be revealed as God hath said vengeance is mine I have suffered innocently more than a thousand deaths I know there will be no punishment for me in the next world, where the trials and tribulations will never be repeated; as God is my witness as this is my last dying assertion is my hopes my innocence be revealed, I leave this mortal body with conviction and solace that I have nothing to reproach myself for George H. Arnold's death or his mysterious disappearance for which God knows will hold me guiltless. My punishment is unbearable in all its detailing, may be charged in my entering against my principal in the sale of intoxicating liquors, which is this day the chief ruination of our country in causing crime.*

The last portion was handwritten on the back of Arnold's typed will. Pump made a very public disposition of his will, personally delivering a copy of it to Reverend W.S. Potter, who leaked to the press that the WCTU was to be the beneficiary of his estate. With a twisted sense of irony, he also gave the reverend a copy of a book, *On Crime*, which had been in his family for years. While it seemed that Pump was turning a new leaf, it is more likely that this was little more than a public relations ploy on the part of the wily old man, attempting to sway public opinion of him after his conviction.

On March 20, Pump finally made bail for the last time. The $6,000 was paid by some of Battle Creek's most prominent citizens: John Watkins, E.C. Hinman, John Helmer, Nelson Eldred, Henry Larkin and Joseph Ward. With such prominent names backing his release, one must wonder if Pump had information on any or all of them. There was a genuine fear in the community that Pump might "get even" with those who he felt had wronged him during his trial. He arrived in Battle Creek at about 3:00 p.m. and then retired to his home on Jefferson Street.

Pump didn't appear in public often after his return to the city. Speculation abounded that he was ill or was plotting vengeance. In April 1896, the WCTU and YMCA announced the opening of the Arnold Mission in one of the storefronts of the Arnold Block. Named for Maria, the WCTU seemed to be anticipating the inheritance of Pump's estate.

Pump stayed at his residence on Jackson Street, rarely venturing into public after his release. In an account in the *Battle Creek Moon* newspaper:

> *The old man has not slept in his house since two years before his wife died. She was very nervous and suffered considerably, and he could not stand to see it. The "It" gets means for him, and when the housework is finished, paints pictures which he frames and hangs upon the wall. His specialty is flowers and fruit, but no one outside of Detective Lally in Detroit could identify the variety.*
>
> *"George had a forgiving disposition and would not haunt anyone that killed him," the old man said to Effie Mead. This remark is an index to the old man's superstitions. He believes that spirits return and vex anyone who injures them in life, and those who see him in the block, prowling along all night, say he acts as if he is haunted by the spirit of his wife. The slightest reference to her brings the tears. "Oh, she was a good woman," the old man said. "She was always doing good and during our entire married life we never had a quarrel. She was always investigating some unfortunate person's condition and relieving distress, and I am glad I gave her whatever money she wanted. She stuck by me through everything, and I know she is in heaven. That's where she belonged."*

Given Pump's reputation and activities, any number of ghosts may have been plaguing his attempts at sleep.

By December 1896, with his case on appeal to the state Supreme Court, Arnold's health began to turn. Per the December 12 issue of the *Battle Creek Daily Journal*: "Adam C. Arnold has failed steadily the past few

weeks, is confined to his bed, and delirious much of the time. It is only a question of time with him as there are no prospects of his recover, and it is quite probable death may ensue before his appeal case comes before the Supreme Court."

One month later, the ever-biting *Battle Creek Moon* newspaper offered a different interpretation of Pump's health. It claimed that Arnold was shaming the public. Those who claimed that Pump was delirious were merely fooled with an elaborate ploy. Those watching for his death were reporters from the Chicago and Detroit newspapers. Arnold was big news. His reputation as a criminal and his committing the heinous act of killing his only son made him a matter of interest. Even the newspaper in Oneida, New York, reported updates of his condition. For the first time in his life, he got the scope of the notoriety that he had so craved.

Fred McDonald was an unattractive young man whom Arnold took under his wing. Per the *Battle Creek Daily Journal* years later, "Macdonald [*sic*] was brought here many years ago by Arnold, and it is claimed by some, was adopted into the family. Whether adopted as his son or not, McDonald always lived in the Arnold family and did the entire housework, baking, cooking, washing, ironing, sewing, etc., doing all the duties usually performed by a woman."

Arnold's declining health was no ploy on his part. On March 4, 1897, at 7:20 a.m., the "Greatest Criminal Who Ever Lived in the City of Battle Creek" passed away. He was attended by Fred McDonald and his "nurse," Frank Coon:

> *When the last person had deserted old Arnold, McDonald remained true to him and administered to his comforts until he died. He always insisted that Arnold did not kill his son George. When the last hours came to Arnold, he clung to McDonald as his only surviving friend and insisted that he sit up nights and watch by his bedside. Arnold would not remain alone for an instant in the dark and insisted that his room be lighted and the lamp left burning all night. He could not remain alone in the dark with his conscience. He heard and saw things in the dark that brought terror and remorse. When the last came McDonald was by Arnold's bedside as faithful in the hours of death as he was when Arnold was enjoying his full degree of health and living under far different conditions.*

Arnold remained in his home at 100 West Jefferson Street until his death. According to them, Arnold had been in a state of state of semi-consciousness

for two weeks. Before that, as his health waned, Arnold remained resolute about his role in George's murder. "He made no confession of guilt. When conscious during his sickness he has earnestly asserted that he was not guilty of the murder of George and that he had no knowledge of how he came to his death. He admitted that he had been a bad man all of his life but that he was innocent of the death of his son," according to McDonald, who spoke to the *Battle Creek Moon*. On his last day, in a delirium, he imagined that his wife and son were with him at his bedside.

The *Detroit Journal* reported it differently. It claimed to have a source that Arnold gave a deathbed repentance, but even if he did, "it cannot wipe out all the evil he did in life."

His funeral took place on March 6, with a surprising number of people stopping by his house to view his remains. No doubt many showed up just to be sure that the scourge of Battle Creek was truly dead. Reverend Potter officiated his ceremony at 2:00 p.m., and Pump was interred at Oak Hill Cemetery next to his wife and son. Ironically, he was buried next to Erastus Hussey, a Quaker pastor who had been a conductor in the Underground Railroad in the city during the Civil War and had been one of the founders of the Republican Party. Battle Creek's most infamous criminal was interred next to one of its most pious, upright and revered citizens.

Pump's ultimate act of vengeance (and humor) on the community didn't become fully known until April 22, 1897, when his will was entered into probate. Pump's willing his estate to the WCTU seemed magnanimous on the surface, but before he drafted his new will, he had signed several pieces of his property over to those men who had put up his bail. The most valuable asset, the Arnold Block, had been signed over to Fred McDonald before the will had been drafted. Mrs. Luella Farley, the president of the WCTU, had already ordered the grave marker for Pump and his family, anticipating a windfall of thousands of dollars. What Mrs. Farley learned was that Arnold's empire was mostly a matter of paper and promises. Some of his properties were delinquent on taxes, while others had long-standing mortgages.

Pump Arnold had extracted his last bit of revenge on Battle Creek and what he saw as the meddlesome WCTU. He had gotten the organization to purchase his headstone and had essentially stiffed it with the bill—all based on the promise of an estate that simply didn't exist.

EPILOGUE

If old Leek knew of the dark deed, he held his tongue well. He became afraid, several years after the old man's death, that Arnold's ghost was haunting him and would go on to the county jail and insisted on being cared for. But haunted as he believed he was, he was constant to the vow that he doubtless made and never revealed by a word that he knew aught of the crime more than was consistent with innocence.
—Battle Creek Daily Moon, *"Six Months Dead and Unburied,"*
April 4, 1902

With Adam Arnold's death, his varied and nefarious criminal activities drifted into the collective memories of the city. The citizens of Battle Creek did not deliberately seek to purge him from their memories or the landscape of the city—time and neglect would do that for them. Like most cities, Battle Creek struggles even today to try to preserve its history, and attempts were made to save the iconic landmarks that made up Pump's empire, no matter now tainted by his criminal activities. Preservation is less of a struggle against time and the elements as it is against money and profits.

Part of the problem was that at the turn of the century, Battle Creek was undergoing a massive amount of change. Arnold's departure came at a pivotal time in the history of the city that had been his home. In a few short years, the Seventh-Day Adventist Church would leave the city, abandoning it as a world headquarters. The church's tabernacle burned in 1902, and for the prophesy-driven Adventists, it was treated as a sign. In reality, the church was becoming overburdened in Battle Creek. The printing business

declined, and with every economic downturn in the economy, more church members came to Battle Creek seeking jobs or assistance from the church. A move to a new headquarters location was inevitable.

One of the Seventh-Day Adventist's great offshoots, Dr. Kellogg's infamous sanitarium, became what Battle Creek was known for through the end of the Victorian era. From that, two massive breakfast cereal empires would emerge: Post and Kelloggs. Both would dramatically alter the landscape and workforce of the city.

Pump's deeding of the Arnold Block to Fred McDonald and then willing the property to the WCTU was, in the eyes of many, a deliberate act. Further complicating matters, Fred McDonald had let the property lapse for taxes back into the receivership of the City Bank. Newspapers estimated that Arnold's estate was worth somewhere between nothing and $100,000. Arnold's last-minute twist to his will left the WCTU holding the proverbial bag when it came to the rights of ownership over the structure. It was a legal struggle that took years to resolve. A mission was opened in the Arnold Block in November 1896, at the behest of the WCTU and a local church. The former den of sin became a refuge for the downtrodden in the city. A lunch counter and temporary bedding were provided. Only a few blocks from the Michigan Central train station, it became a stopping point for any tramp who rode the lines between Chicago and Detroit. The presence of the mission only seemed to lower the value of the properties along the canal.

After years of operation, the mission eventually closed. A few businesses rented the structure, but the small side street did not garner much pedestrian traffic. In 1983, an antique business, Pump Arnold's Place, opened in the Arnold Block. The Battle Creek Historical Society successfully filed to have the structure protected on the National Register of Historic Places, citing its ornate glazed exterior Italian tiles and wrought-iron work as a reason to save the building. The business was open for a few years but eventually closed.

Even today, there are whispered rumors that Pump had buried a hoard of gold in the basement of the Arnold Block. Those were just rumors. If anyone could have figured out a way to take his money with him, it would have been Pump Arnold.

Paulina Hamilton won her case regarding the stolen plums against Arnold's estate in 1898. The final award, after all appeals and countless dollars of legal fees was $10,000. Her victory was purely a moral one, though. If she had thought to reap the rewards of Arnold's estate, there was nothing left for her damages.

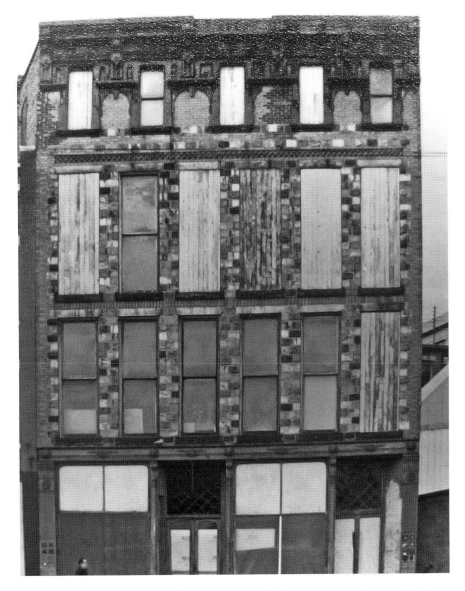

The abandoned Arnold Block, still showing some of its former glamour. *Courtesy of Heritage Battle Creek.*

Battle Creek, like many communities, struggles even today to save historic structures. Such was the case with the Arnold Block. While the National Register protects structures from being demolished with federal money, nothing could prevent its demise at private hands. The Arnold Block was

torn down to put up the new home of the Kellogg Foundation. Pump's monument to the sins of mankind has been replaced by one of the world's leading charitable organizations—proof of universal karma if nothing else.

The statue of Mayor Gage, which had been the subject of much ridicule and amusement in Battle Creek, disappeared from Charles Hovey's farm in 1907 for two years. Hovey eventually tracked it down to a farm in Three Rivers, Michigan, and returned it for a short time to his home. In the later years of his life, he moved the statue to a resort he had created in Manistique, Michigan. Since 1931, the statue has stood outside one of the lodges. It remains as the sole tangible physical evidence of Arnold's revenge on the mayor who tried to take him down.

The Exchange Hotel, where Pump started his fortune, exchanged hands and names many times, becoming known variously as the Jefferson, the Republic and the Alhambra and eventually falling into disrepair. It became even more isolated when the Grand Trunk Railroad opened its new station more than one mile away. The only appeal the hotel had ever possessed was its proximity to the train station, and that was gone. The barn where Pump and Samuel Snediker changed clothing and identification caught fire from sparks from a passing railway engine in 1908, burning to the ground.

In 1919, complaints about the structure came to the attention of the health board and the city council. They inspected the old clapboard structure and were disgusted to discover more than a foot of stale green water in the basement of the structure. The Jefferson Street structure was known to have been built on soggy ground decades earlier, so seepage was a forgone conclusion. The sanitary conditions of the building were horrific. The residents of the old hotel complained of constant illnesses, and the city met late at night to condemn the building.

J.R. Kirkpatrick, a local coal seller, purchased the building and set out to renovate it, which meant little more than pumping the water out and repapering and painting the building. While the structure passed a health inspection, it was deemed that it was more suitable to Battle Creek's burgeoning black community. "Members of the colored race coming to Battle Creek have found it practically impossible to find a decent place to stay in the city and it is hoped that the new hotel will take care of this difficulty." The old building was eventually torn down in 1936.

Arnold's home at 100 Jefferson Street saw several different owners, including Samuel Irwin and Edward Derby. By 1917, the home had become run-down and was torn down to put up a garage. In 1957, the garage was

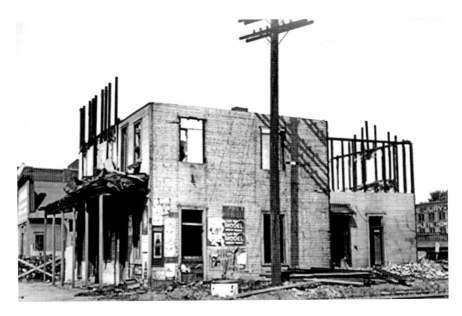

The Exchange Hotel/Arnold House in 1936 when it was being demolished. *Courtesy of Willard Library, Battle Creek.*

torn down, leaving no trace of the former owner and inhabitant who had held Battle Creek in his sway for years.

Since then, the landscape has changed dramatically. The railroad tracks were repositioned, as was the Kalamazoo River—part of a flood containment program. Bit by bit, every hint of old Battle Creek morphed and transformed. Like many cities of its size, even the echoes of its past faded into memory.

John Leek, Arnold's personal manservant, worked for years at the New Herndon Hotel in Marshall and doing odd jobs in the city. When he became ill, he went to the police station, where Chief Farrington took him to the hospital. Leek never recovered and passed away at the Nichols Hospital on October 4, 1901. As he lay on his deathbed, officers came to him to see if he had any dying revelations regarding Pump Arnold. Even in his delirium, Leek seemed to feel the grip of Pump on him. He died without revealing any details of his possible role in the placement of George Arnold's body. When Leek died, the chief of police could not find any living relatives. The undertaker in town decided to use Leek's body to experiment with a new preservation technique. After his mortal remains were treated, they were remarkably well preserved, even six months later. His body was put on display with the Michigan Association

of Embalmers when it came to Battle Creek for its annual meeting in 1902.

Fred McDonald, Pump's "adoptive son" and close confidant, died at his home on Maple Street on May 24, 1904. The young man he lived with had left to go to a party at nearby Gull Lake. Upon his return, he thought that McDonald was asleep, but when he couldn't awaken him the next morning, he summoned a doctor. Arnold's close companion died of a brain hemorrhage.

Per the *Battle Creek Daily Journal*, "He was strange and odd in his ways and never associated to any great extent with men. His personal appearance was so unattractive that he repelled people from him. Having a consciousness of this fact it made him very sensitive, and that is one reason he lived by himself and to himself and had very little to do with other people." To his dying day, he insisted that Pump had nothing to do with the death of George.

But was that the case? In 1898, the *Sunday Record* newspaper printed a page-one story from a paid source, a "hired man," who claimed to know exactly what had happened to George Arnold the night that he died. The source, while never named, had to have been someone on Arnold's inner circle if the account is indeed true. The story claimed, "I am positive there was a fierce struggle between father and so, for the words and blows were heard by at least one person, but the blows and choking that George received would not have caused the death of a healthy man." It went on to claim, "George did not recover as I understand it. It is doubtful if he ever regained consciousness. After working over him for a time the father summoned help, not the help of a physician, for he was fearful of discovery, but the help of a strong man who was requested to convey the injured man to the basement of the building."

George didn't die because of the beating, per se, but rather from his weakened condition:

> *George Arnold was not murdered in the strictest sense of the term, and Arnold's dying protestations of innocence were true. The injuries the young man received that night would have not kept a well man in bed one day, but Arnold did not consider the feeble condition of his son when struggling with him. The only wonder is that a man of Arnold's natural shrewdness could not have devised a better way of handling the matter. If he had called a physician that night had told the exact truth regarding the matter, he would never have been arrested and tried for murder. For, according to my theory, George died from the effects of alcohol, and not from the effects of the beating he received.*

Three years after Pump's death, the murder was still page-one news. The details provided point to inside information. If the source was not Fred McDonald, he may have been the source's source. McDonald not only took his secrets to the grave with him but also returned to the side of his former employer. He was interred in the Arnold family plot, laid beside Pump for all time.

After Arnold's death, Battle Creek underwent another metamorphosis, shifting from a Midwest industrial city into the cereal capital of the world. While heavy industry would always play a part in the city, what emerged from the Battle Creek Sanitarium was an entirely new industry centered on breakfast. The first corn flake was made there in 1898. Dr. Kellogg's brother, William Keith Kellogg, recognized the potential and turned the food served at the San into something that would transform breakfasts everywhere. Charles W. Post, a former San patient himself, also recognized the market and formed the Post Company. Two cereal giants were flanked by more than two dozen other biscuit and cereal manufacturers. Battle Creek transformed itself into a city that served breakfast to the world. History split, like a fork in a river. There was the era of "Cereal City" and its early industrial past.

If you travel to Battle Creek to look for signs of Pump Arnold, there are none. Historians strain to find any tangible contribution that he made to the city other than to be an example of all that is bad in the eyes and hearts of man. He is remembered more as an anomaly, a "colorful character." Even today, on graveyard tours, local historians dress up as Arnold to entertain the locals with the tale of the statue of Mayor Gage.

Arnold was many things, but in the end, he is best known for the hideous crime of killing his own son, yet this is often glossed over. He built and devoured an empire and flaunted his power openly. Adam C. Arnold taunted the citizens and politicians of the city even after his death.

We like to tell ourselves that men like him could not exist today, but they do. The closest equivalent might be the barons of Wall Street, who manipulate financial crises and laugh all of the way to the bank. Perhaps that is his legacy, as well as the reason why such men should be studied. While the techniques and legalities change, there will always be men of Arnold's ilk, lurking in the shadows and ready to exploit the weaknesses of others for their own advancement.

If he were alive today, he would level lawsuits at both of the authors of this book for misrepresenting him. Worse yet, he might win!

BIBLIOGRAPHY

BOOKS

Lowe, Bernice Bryant Lowe. *Tales of Battle Creek*. New York: Albert L. and Louise B. Miller Foundation Inc., 1976

Massie, Larry B., and Peter J. Schmitt *Battle Creek: The Place Behind the Products*. New York: Windsor Publications Inc., 1984.

Pioneer Days in Old Battle Creek: An Illustrated and Descriptive Atlas of a City in the Making. Battle Creek, MI: Central National Bank and Trust Company, 1931.

Portrait and Biographical Record of Kalamazoo, Allegan and Van Buren Counties. Chicago: Chapman Brothers, 1892.

Ross, Coller H. *Battle Creek's Centennial*. Battle Creek, MI: Battle Creek Enquirer and News, 1959.

A Tour Through the Past and Present of the Battle Creek Federal Center. Washington, D.C.: U.S. Government Printing Office, 1981.

MAGAZINES

Starbuck, James C. "The Michigan Military Academy at Orchard Lake." *Michigan History* (September 1966). Michigan Historical Commission.

BIBLIOGRAPHY

ARCHIVAL MATERIALS

Heritage Battle Creek, Pump Arnold File.

The People v. Adam C. Arnold. Michigan Supreme Court Ruling, 1882.

Willard Library, Collier Collection. Local Photographic Archives, Battle Creek, Michigan.

NEWSPAPERS

Battle Creek Daily Journal. "A.C. Arnold, His Examination This Morning." March 22, 1880.

————. "A.C. Arnold, His Examination This Morning, He Is Being Held on Two Charges." March 22, 1880.

————. "Adam C. Arnold." February 17, 1896.

————. "Adam C. Arnold." February 16, 1895.

————. "Admitted to Bail." February 27, 1895.

————. "After Adam." April 25, 1895.

————. April 9, 1883.

————. "Arnold Arrested." February 8, 1895.

————. "Arnold Case." April 30, 1895.

————. "The Arnold Case." April 8, 1880.

————. "The Arnold Case." April 9, 1895.

————. "The Arnold Case." April 6, 1895.

————. "The Arnold Case." April 7, 1880.

————. "The Arnold Case." April 10, 1895.

————. "The Arnold Case." February 18, 1895.

————. "The Arnold Case." February 25, 1895.

————. "The Arnold Case." February 21, 1895.

————. "The Arnold Case." February 26, 1895.

————. "The Arnold Case." March 27, 1880.

————. "The Arnold Case." March 26, 1880.

————. "The Arnold Case." May 13, 1880.

————. "The Arnold Case Appealed." January 14, 1896.

————. "Arnold Examination." April 29, 1895.

————. "The Arnold Inquest." February 7, 1895.

————. "The Arnold Inquest." February 13, 1895.

————. "Arnold Murder." April 2, 1895.

————. "Arnold Released." March 20, 1896.

————. "Arnold's Examination." April 27, 1895.

———. "Arnold's Examination." February 19, 1895.

———. "Arnold's Examination." February 20, 1895.

———. "Arnold Statue." February 20, 1896.

———. "Arrested at the Arnold House." August 28, 1879.

———. "Arrested for Larceny." July 29, 1879.

———. "Arrested." January 22, 1884.

———. "Bell's Crooked Transactions." March 16, 1880.

———. "Brevities." April 21, 1891.

———. "Brevities." February 19, 1891.

———. "Brevities." February 28, 1893.

———. "Brevities." October 12, 1894.

———. "City Courts." May 11, 1878.

———. "Concerning Arnold." February 9, 1895.

———. "Conspiracy Charged." March 3, 1880.

———. "Conspiracy Charged." March 20, 1880.

———. "Court." July 21, 1887.

———. "Court and Crime." April 9, 1883.

———. "Court and Crime." June 14, 1890.

———. "Courts and Crime." December 12, 1890.

———. "Crazy Woman." August 8, 1879.

———. "Dailies." April 2, 1896.

———. "Dailies." December 12, 1896.

———. "Eccentric Character, Fred C. MacDonald, the Last Living Friend of the Notorious Adam C. Arnold, Has Passed Away." May 25, 1904.

———. "George H. Arnold, the Body of the Missing Man Found This Morning." February 1, 1895.

———. "Houses of Ill Fame or Assignation." April 22, 1859.

———. "The Inquest." February 14, 1895.

———. "In the River, There the Body of Isaac Harrison Was Found." December 26, 1894.

———. "Journal Jottings." April 21, 1890.

———. "Legal." February 24, 1893.

———. "Legal." November 1, 1889.

———. "Legal Bits." December 30, 1893.

———. "Legal Notices." November 9, 1886.

———. "A Little 'Unpleasantness.'" June 3, 1879.

———. "Local News." December 20, 1894.

———. "Local News." December 21, 1894.

———. "Local." August 20, 1886.

———. "Local." July 31, 1883.

———. March 3, 1878.

———. "More Mystery." February 11, 1894.

———. "Obituary." August 25, 1892.

———. "Personals." December 24, 1877.

———. "Personals." January 22, 1884.

———. "Personals." September 18, 1877.

———. "Personals." September 19, 1877.

———. "Serious Affray." October 30, 1889.

———. "A Test Case." August 31, 1882.

———. "Wanted Information." December 19, 1894.

Battle Creek Daily Moon. April 21, 1888.

———. "The Arnold Case, Further Testimony in the Sturgis Justice Court." April 8, 1880.

———. "Business." March 21, 1888.

———. "Captured." February 25, 1893.

———. "Court and Crime." February 25, 1893.

———. "Court and Crime." October 18, 1893.

———. "Criminal Cases." May 26, 1892.

———. "Disorderly Characters." August 24, 1893.

———. "His Lips Were Sealed, John Leek Died without Making Reference to the Arnold Murder." November 20, 1901.

———. "An Important Arrest." February 26, 1890.

———. "Local." January 18, 1888.

———. "Local News." November 18, 1886.

———. May 6, 1880.

———. "Moon Beams." April 5, 1893.

———. "Moon Beams." April 20, 1891.

———. "Moon Beams." August 8, 1892.

———. "Moon Beams." August 4, 1892.

———. "Moon Beams." August 20, 1891.

———. "Moon Beams." December 17, 1887.

———. "Moon Beams." December 17, 1886.

———. "Moon Beams." December 16, 1886.

———. "Moon Beams." February 27, 1893.

———. "Moon Beams." January 18, 1888.

———. "Moon Beams." January 19, 1891.

———. "Moon Beams." January 17, 1891.

———. "Moon Beams." January 24, 1888.

———. "Moon Beams." July 31, 1893.

———. "Moon Beams." July 21, 1891.

———. "Moon Beams." June 5, 1889.

———. "Moon Beams." June 14, 1890.

———. "Moon Beams." June 4, 1889.

———. "Moon Beams." June 12, 1890.

———. "Moon Beams." March 2, 1888.

———. "Moon Beams." March 6, 1890.

———. "Moon Beams." March 3, 1890.

———. "Moon Beams." May 5, 1893.

———. "Moon Beams." November 4, 1890.

———. "Moon Beams." October 14, 1889.

———. "Moon Beams." September 9, 1889.

———. "Moon Beams." September 16, 1891.

———. "Moon Light." December 19, 1894.

———. "Moon Rays." July 21, 1887.

———. "Moon Rays." November 9, 1887.

———. "Moon Rays." October 15, 1887.

———. "Moonbeams." August 10, 1887.

———. "Moonbeams." August 21, 1886.

———. "Moonbeams." August 24, 1888.

———. "Moonbeams." May 16, 1888.

———. "Moonbeams." November 8, 1886.

———. "Moonlight." December 19, 1887.

———. "Moonlight." December 25, 1892.

———. "Moonlight." December 27, 1894.

———. "Moonlight." March 30, 1891.

———. "Moonlight." November 14, 1890.

———. "Moonlight." September 14, 1891.

———. "Moonlight." November 19, 1890.

———. "Moonlight." November 13, 1890.

———. "Moonlight." November 22, 1890.

———. "Moonshine." April 2, 1889.

———. "Moonshine." November 4, 1889.

———. "Moonshine." November 12, 1889.

———. "News Rays." August 26, 1889.

———. "Personalities." January 19, 1894.

———. "Personalities." November 9, 1893.

———. "Personalities." October 24, 1893.

———. "Prostitution Arrests." August 25, 1893.

———. "The Recorder's Court." March 23, 1891.

———. "Six Months Dead and Unburied." April 4, 1902.

———. "Sparks Cause Fire." June 2, 1908.

———. "Still Missing." December 21, 1894.

———. "A Street Row." April 20, 1888.

Battle Creek Enquirer and Evening News. "Do You Remember?" April 2, 1922.

———. "Pump Arnold's Old Hotel Is Condemned by the Board of Health." May 13, 1919.

———. "To Open a Hotel for Negroes Only." June 25, 1919.

Battle Creek Enquirer. "Battle Creek City News." May 25, 1860.

———. "Early Woolen Mills." June 5, 1916.

Battle Creek Evening News. "Historic Arnold Block Transferred Saturday." January 20, 1913.

Battle Creek Journal. "Arrested for Larceny." July 29, 1879.

———. "Brevities." August 28, 1879.

———. June 7, 1876.

———. "Legal Notice." February 2, 1880.

———. "Neither Absent or Tardy for the Year." July 26, 1876.

———. "Not So." August 6, 1879.

Battle Creek Moon. "A.C. Arnold—It is Believed that His Death Bed Sickness of Feigned." January 26, 1897.

———. "Adam C. Arnold." April 27, 1895.

———. "Adam C. Arnold." February 25, 1895.

———. "Adam C. Arnold, Now Behind Bars in a Marshall Jail." February 9, 1895.

———. "Again Adjourned." March 4, 1895.

———. "Alhambra Hotel Is Old Landmark." March 11, 1921.

———. "Arnold Adjourned." March 28, 1895.

———. "Arnold Dead." March 4, 1897.

———. "The Arnold Mystery." February 2, 1895.

———. "Arnold's Will, It Was Admitted to Probate Today, No Property Will Be Left." April 22, 1897.

———. "Crime—Arnold's Career." February 8, 1895.

———. "Examination." February 16, 1895.

———. "The Examination." February 20, 1895.

———. "He's a Puzzler, A.C. Arnold the Queerest Character in the State." February 11, 1895.

———. "His Body Found, How Did George Arnold Come to His Death?" February 1, 1895.

———. "Indignation." February 28, 1895.

———. "In Jail, Is A.C. Arnold, Charged with the Murder of His Son." February 8, 1895.

———. "The Inquest." April 15, 1895.

———. "The Inquest." February 14, 1895.

———. "The Inquest." February 7, 1895.

———. "It Was a Murder." February 19, 1895.

———. "It Was Murder." February 5, 1895.

———. "John Leek Talks!" February 26, 1895.

———. "Leak in Fear." April 16, 1895.

———. "Moonbeams." March 9, 1897.

———. "Moon Light." February, 11, 1892.

———. "Moonlight." February 4, 1895.

———. "Moonlight." March 6, 1897.

———. "More Mystery, Coming Out About the Famous Arnold Murder." September 1, 1897.

———. "More Mystery. Coming Out of the Famous Arnold Trial." September, 1, 1897.

———. "Murder Will Out." April 2, 1895.

———. "Personalities." May 24, 1895.

———. "Still a Mystery." February 6, 1895.

———. "The Story Told." April 2, 1895.

———. "$10,000 in Damages." April 25, 1895.

———. "Testimony In." April 30, 1895.

Battle Creek Moon Journal. "The Early Industries of Battle Creek." January 27, 1917.

———. "He Is Missing." December 18, 1894.

Battle Creek Nightly Moon. "Adam C. Arnold, How He Acts and Talks In the County Jail." May 6, 1880.

———. "Moonlight." February 3, 1885.

———. "Notice." November 17, 1880.

———. "Out of Prison." November 13, 1880.

———. "Reformed." April 16, 1881.

———. "Revenue Raid." April 8, 1881.

Battle Creek Tribune. "The Arnold Liquor Case." September 9, 1882.

———. "Arrested." September 23, 1882.

————. "This and That." September 30, 1882.

Citizen. "The Arnold Liquor Case." September 9, 1882.

————. "Lightning Struck. A.C. Arnold, the Victim." September 4, 1882.

————. "Local News." September 30, 1882.

Daily Chronicle. "Brevities—The Arnold Case." May 1, 1895.

Daily Journal. "Disastrous Fire!" August 18, 1873.

Detroit Free Press. "Throwing Vitriol." May 26, 1860.

Enquirer and News. "The City Editor's Notebook." October 1, 1963.

Evening Chronicle. "Local News." January 29, 1895.

Evening News. "Historic Arnold Block Transferred Saturday." January 20, 1913.

Expounder. "Locals." June 3, 1904.

Kalamazoo Gazette. "Another Victim." December 27, 1895.

————. "Arnold's Statue." February 19, 1896.

————. "Arnold's Trial." December 18, 1895.

————. "Arnold's Trial." December 11, 1895.

————. "Arnold's Trial." December 17, 1895.

————. "Arnold's Trial Begins Today." December 9, 1895.

————. "The Arnold Trial." December 13, 1895.

Marshall Daily Chronicle. "Court Appearances." March 2, 1883.

Marshall Statesman. "Arnold Murder Trial." December 23, 1895.

————"The Arnold Murder Trial Is Now Underway." December 13, 1895.

————. "Battle Creek Bits." April 13, 1883.

————. "Held for Trial." May 1, 1895.

————. "Trying Adam." December 20, 1895.

Michigan Tribune. "Chancery Sale." February 2, 1880.

————. "Court and Crime." April 2, 1881.

————. "Court and Crime." August 17, 1878.

————. "Court and Crime." March 27, 1880.

————. "Crimes." April 2, 1881.

————. "Localities." December 10, 1881.

————. "Tid Bits." August 27, 1881.

————. "Wary of Life, in Its Early Morning, Anna Whittmore and Cora Colburn Attempt Suicide." August 27, 1881.

Milwaukee Journal. "Saloon Keeper's Revenge: Or 'This Is Our Mayor.'" August 20, 1929.

New Era Gleaner. July 16, 1894.

New York Sun. The Extra Sun. April 19, 1856.

————. "Local Events." April 14, 1856.

Nightly Moon. "Courted, the Experience Adam C. Arnold Is Undergoing." November 10, 1880.

―――. "Let Us Alone, the Plea of Mr. and Mrs. A.C. Arnold." April 14, 1881.

―――. "Reformed." April 16, 1881.

―――. "Revenue Raid!" April 9, 1881.

―――. "Stabbing Affray." March 22, 1881.

Oneida Sachem. April 12, 1856.

―――. "Fire!" March 22, 1856.

―――. May 10, 1856.

―――. May 3, 1856.

―――. "Mortgage Sale." December 29, 1855.

―――. "Mortgage Sale." December 22, 1855.

―――. "Mortgage Sale." January 5, 1856.

―――. "Mortgage Sale." November 17, 1855.

―――. "Mortgage Sale." November 24, 1855.

―――. "Mortgage Sale." October 20, 1855.

―――. "Notice." January 5, 1856.

Oneida Whig. "Chancellery." September 13, 1838.

―――. "Legal." March 21, 1837.

Roman Citizen. "Warrants." May 7, 1856.

Rome Daily Sentinel. "The Death of Adam Arnold." March 8, 1897.

Rome (NY) Roman Citizen. "Legal Notices." January 2, 1856.

―――. "Legal Notices." January 5, 1856.

Sunday Daily Record. "The Old Arnold Organ." November 13, 1898.

Sunday Record. "Our Hired Man, What He Thinks He Knows About the Arnold Case." June 18, 1898.

INDEX

ABOUT THE AUTHORS

Blaine Pardoe is an award-winning, best-selling author of *Lost Eagles* and *Murder in Battle Creek*. Blaine was raised outside Battle Creek and received his bachelor's and master's degrees from Central Michigan University. Victoria R. Hester is a graduate of Lord Fairfax Community College and Germanna Community College and resides in Culpeper, Virginia, where she works as a nurse. She has won two prestigious writing awards for her nonfiction work. Blaine and Victoria coauthored *The Murder of Maggie Hume*, a *New York Times* bestseller in crime. They are America's only father-daughter duo writing true crime.

Visit us at
www.historypress.net

...

This title is also available as an e-book